THE LITTLE MERMAID

THE LITTLE MERMAID

Illustrations by

Benjamin Lacombe

Text by

Hans Christian Andersen

English translation of
"The Little Mermaid"
by H. P. Paull, 1872

Original French text
by Jean-Baptiste Coursand
and Benjamin Lacombe

English translation
by Abla Kandalaft

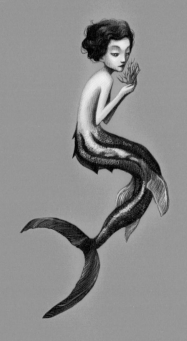

CERNUNNOS

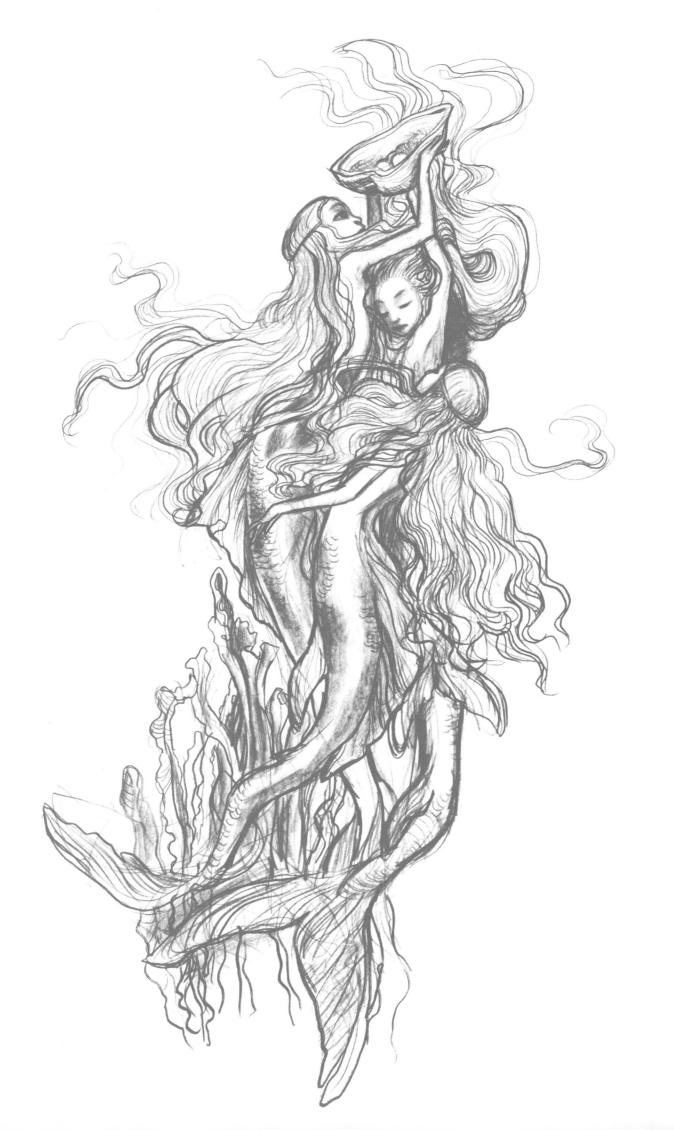

PREFACE

BY JEAN-BAPTISTE COURSAUD

"I don't know anyone who has read it without thinking it was indescribably beautiful," wrote Henriette Hanck to Hans Christian Andersen in 1841. Henriette had been his lifelong friend and was herself a writer. She was of course referring to the story of "The Little Mermaid," four years after its publication on April 7, 1837. The very first trace of the tale appears in another one of Hanck's letters, sent on February 12, 1836, in which she asked about "Daughters of the Air." This was the original title of the story; Andersen had already changed it by May 13, 1836, the day the poet told Hanck in a letter: "God only knows if I will write 'Renzo's Wedding' here or in Fionia. 'The Daughters of the Sea' will be written either in Tolderlund or in Likkesholm, I'll soon know for sure." "Daughters of the Air," subsequently called "Daughters of the Sea," was finally written in a manor in Lykkesholm where Andersen had been living since August 4 and where he worked until January 23, 1837, the date indicated at the end of the manuscript. By that time, the story was called "The Mermaid," and then, in keeping with the editorial process he'd embarked on, Andersen changed it to "The Little Mermaid," its definitive title.

In this third collection of "fairy tales told for children," as he described them, Andersen wrote a short preface specifically for his "older readers." Two paragraphs about "The Little Mermaid" stand out in particular, indicating that this was a tale "whose profound meaning only older [readers] will understand." Could it be that the story has some sort of hidden meaning? "But I do hope," he wrote, "that children will enjoy it, and that the denouement itself will grip them." The exact word used in Danish is quite unique: *opløsning*. It means as much "denouement" as "dissolution," a word that somewhat describes the tragic destiny of the little mermaid. Was Andersen hinting that we should pay attention to this ending, this disintegration? He was keen to stress just how much this tale was "so very different" from his previous work, that the idea "just imposed itself" on him. Why insist so much on the imperious character of literary creation? He even added, in a terse phrase, which was somewhat unusual for him: "I just had to write it." Why this necessity?

The start of the writing process coincided with the date of Edvard Collin and Henriette Thyberg's wedding, on August 10, 1836. Andersen had not been invited and the date of the wedding had been kept from him, even though the Collin family had played a crucial role in his life. Jonas Collin (1776–1861), Edvard's father, was a civil servant and patron of the arts. In his role as director of the Copenhagen Royal Theatre, he had spotted the young Andersen early on. The writer who'd arrived in Copenhagen from Odense in 1819 at the age of fourteen was initially trying to get work as an actor, then a singer, then a dancer, and then a playwright, each time failing to make any headway. In 1822, Jonas Collin appealed to the king in his efforts to fund Andersen's education, and made sure he obtained bursaries and grants throughout his career as a writer.

Their relationship was such that the young poet nicknamed him "Father." In fact, Jonas Collin was father to five children. Two of them were significant figures in Andersen's love life: Louise (1813–1898) and Edvard (1808–1886), whom Hans Christian fell for in turn: the former in 1832 and the latter in 1835.

The mermaid motif was recurrent in the poet's work: In 1832, he wrote a dramatic poem titled "Agnete and the Merman," in which a woman decides to leave her husband, children, and the entire terrestrial world behind to live with a merman in the depths of the sea. The poem was a flop, rubbished by critics and disliked by Edvard, who was also Andersen's reader and had criticized him for being too recognizable as Hemming, Agnete's husband. His inspiration had come from two works of literature: "Undine" by Friedrich de la Motte Fouqué, published in 1811, and a passage from the historical novel of his friend and fellow writer Bernhard Severin Ingemann, *The Creatures Of The Underworld*, published in 1817. Two key devices from "The Little Mermaid" can be found in those works: the German writer's Undine is turned into seafoam, and the Danish writer's mermaid seeks an eternal soul. In fact, Andersen wrote to Ingemann on February 11, 1837:

You will soon receive a new book of tales for children—which you don't like. Heiberg [poet and journalist] has said that it is the best thing I've ever written. You will appreciate this new tale: The Little Mermaid; it is much better than Thumbelina. It is of my own invention and, aside from the story of the little abbess in the Improvisor, the only one of my works that has affected me while I was writing it. You may smile? I do not know how other authors feel but I suffer with my characters, I share their moods, whether good or bad, and I can be nice or nasty according to the scene on which I happen to be working. This new and third collection of fairy tales is clearly the best one and you will like it! Yes, and your wife will like it very much!

What reason did Andersen have to believe that this was his best work, even though he'd barely taken his first steps into this literary genre he'd not yet made his specific mark on—orality, in other words? What was it about this mermaid story that had affected him so? If he claims to suffer "with" his characters, it must be that somehow he identifies with them, right? How? With which one? What sentiment drives him to the point of being nasty? Towards whom and for what reason? Who does he wish to spare by remaining nice?

So many questions—on top of the aforementioned ones—which we will endeavor to answer in the afterword. But first, let us read this story in a new light, and then cast our eyes on a collection of love letters written by Andersen to Edvard and Louise Collin that will provide us with some keys to understanding the inspiration behind "The Little Mermaid."

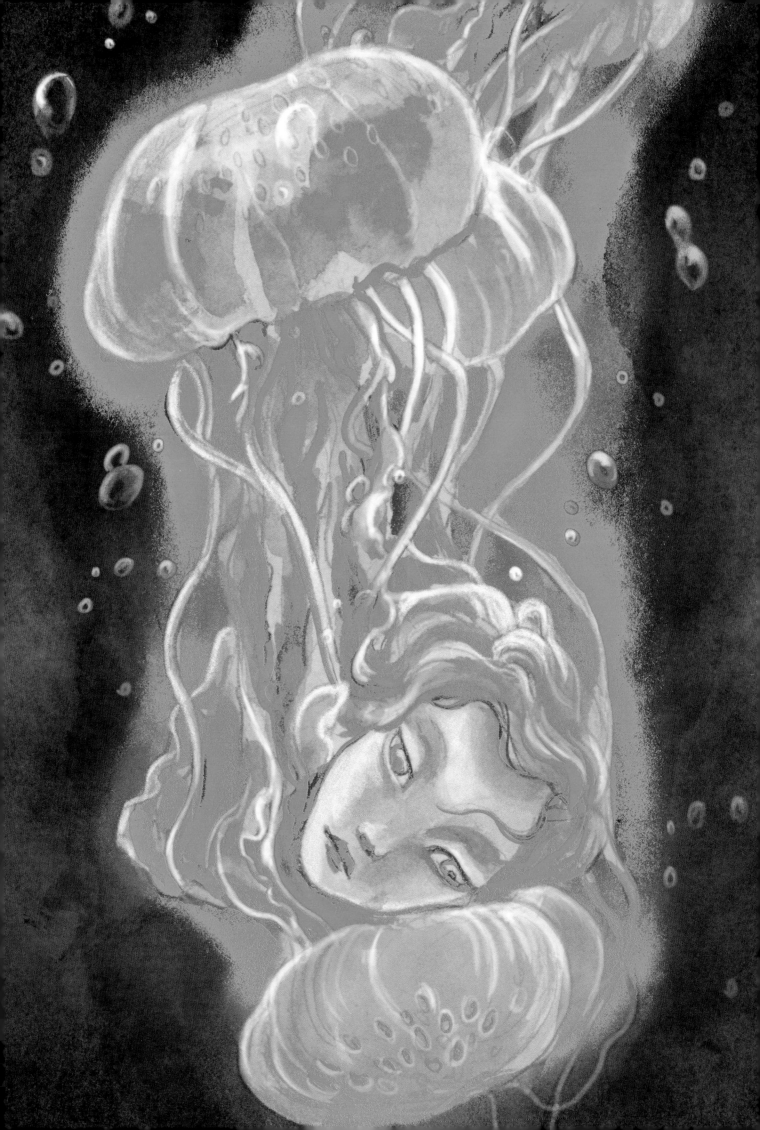

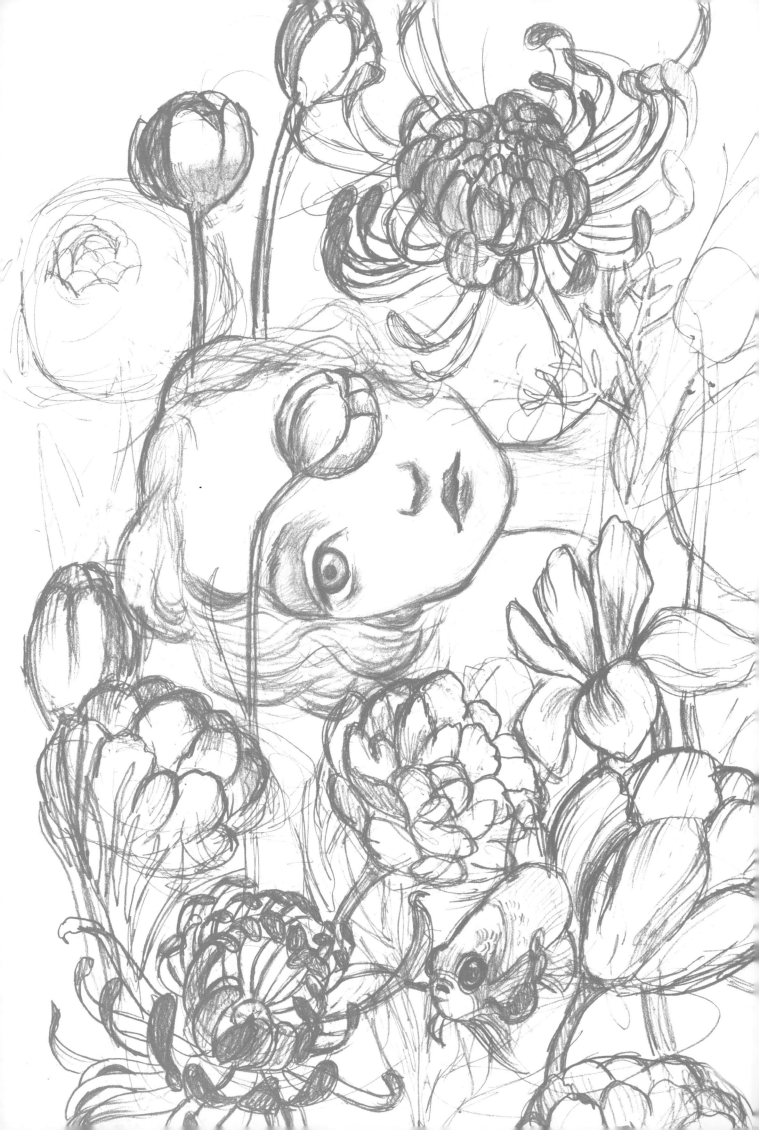

My Little Mermaid

by Benjamin Lacombe

I don't personally remember when or how I discovered "The Little Mermaid," given just how much it's embedded in the cultural canon. As a child, I remember being drawn to these characters, this tragedy; the pain of living, felt keenly by the mermaid as if knives were lacerating the soles of her feet, had shocked me, moved me, and resonated with me. I also remember, however, the 1989 Disney version—excessive, colorful, flamboyant. Despite a somewhat softened script, there was a certain ambiguous dimension that gave it a bit more of an edge as the creators, in particular songwriter Howard Ashman, had infused it with references to the New York underground queer scene: Sebastian the crab, who loves opera and fears women; muscly King Triton, the long-haired, diadem-wearing single father; and especially Ursula, the witch of the seas, wholeheartedly inspired by transgressive cult drag queen Divine.

In Hans Christian Andersen's text, this ambiguity is certainly present but is more subtle. In order to gain the prince's love and become human, the little mermaid must mutilate her tail, transform herself, and lose her voice, and thus, her identity. It is in the letters Andersen wrote to Edvard Collin, his boyhood friend and the son of his patrician patron (see page 80), that this metaphorical matrix of the story first takes shape: the unrequited love, the transformation, the ambiguity. Unlike her many sisters, the little mermaid wants to understand her past. Her thirst to uncover the truth behind the enigma of her origin feeds her irresistible attraction to the "world of humans" that seems to hold the answers. She oscillates between two worlds—half human, half aquatic creature—and at fifteen will be able to cross that watery border. A time of physical and psychological transformations, of internal changes and family tensions, and all the other rituals associated with the transition into adolescence.

The prince, however, never really "accepts" the woman in the mute girl that stands before him. He immediately dresses her up as a man, in a squire costume, as if toying with her ambivalence. Had she been human, she could have been loved by the prince. But her origin, her state—neither quite woman, nor quite animal—prevents her from experiencing love, and she must return to her original world. The duty to conform to the expectations of others, of society, without ever fully meeting them is a feeling I've personally felt since my own childhood and that I still feel to this day. I wanted to highlight this dichotomy and the ambivalence of this character by creating a double-being of indeterminate gender.

The hairdo and gaze of my little mermaid bring to mind those of her creator, Hans Christian Andersen, who wrote that he had never felt so close to his characters as he did when writing this story. The purple of her tail, the usual color of the trans-identity that sits between pink and blue, alludes to this fluidity. These colors that run throughout the book are accentuated by a neon-pink Pantone that helps me underline these choices graphically and render the luminescence of the underwater flora and fauna.

I also wanted to toy with forms and shapes, sexualizing some and distorting others to express ambiguity and ambivalence. The translation of the story included in this book offers its readers an ending written on January 23, 1837, by Andersen, crossed out and unpublished, in which the mermaid, upon her death, sheds the weight of her body and is finally able to reveal her true nature and be loved for it.

Andersen wrote to Collin on August 9, 1830: "Remember that the person I truly care about, I weigh their words carefully, especially those that are crossed out, as they are most often the ones that fall from the heart straight into the quill." The author, who was himself a bit of a social renegade trying to unpack his true identity, points in this ending to an era during which gender fluidity had not yet been conceptualized. This was a prescient line of thought that resonates so well today. And so, "The Little Mermaid," with this newly published ending, can be interpreted as a cry from the heart, a cry of love that Andersen could never have expressed whilst he was alive.

Read it with empathy.

THE LITTLE MERMAID

F ar out in the ocean, where the water is as blue as the prettiest cornflower, and as clear as crystal, it is very, very deep; so deep, indeed, that no cable could fathom it: many church steeples, piled one upon another, would not reach from the ground beneath to the surface of the water above. There dwell the Sea King and his subjects. We must not imagine that there is nothing at the bottom of the sea but bare yellow sand. No, indeed; the most singular flowers and plants grow there; the leaves and stems of which are so pliant, that the slightest agitation of the water causes them to stir as if they had life. Fishes, both large and small, glide between the branches, as birds fly among the trees here upon land. In the deepest spot of all, stands the castle of the Sea King. Its walls are built of coral, and the long, gothic windows are of the clearest amber. The roof is formed of shells, that open and close as the water flows over them. Their appearance is very beautiful, for in each lies a glittering pearl, which would be fit for the diadem of a queen.

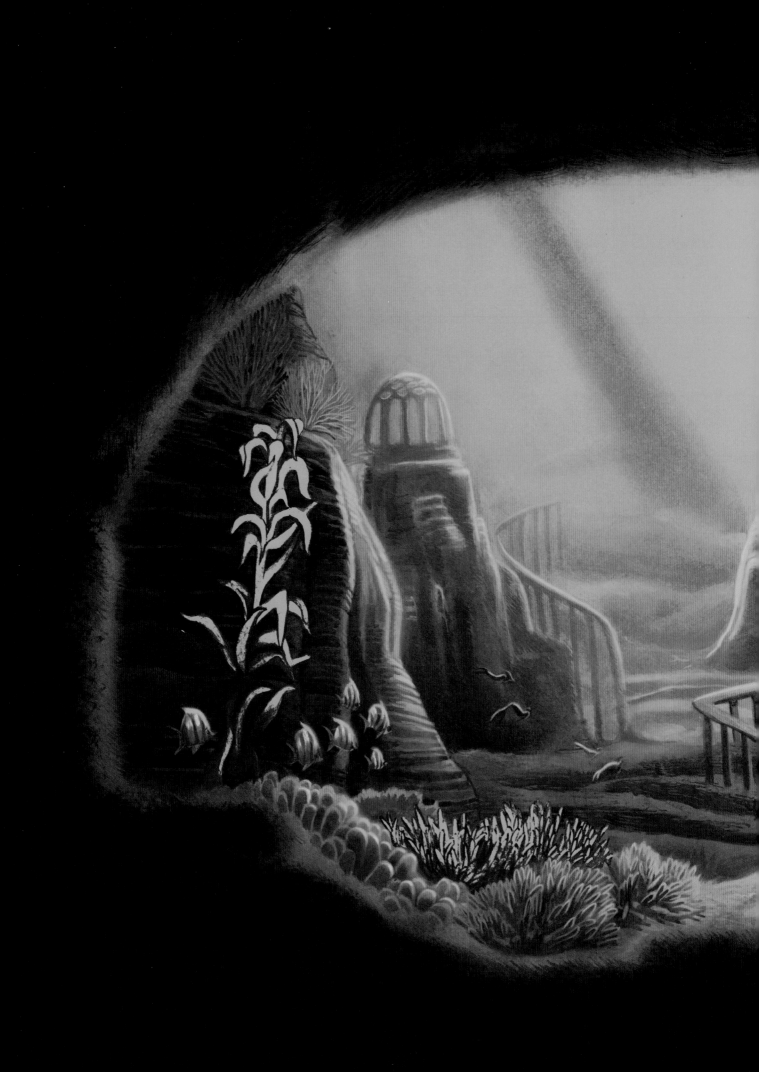

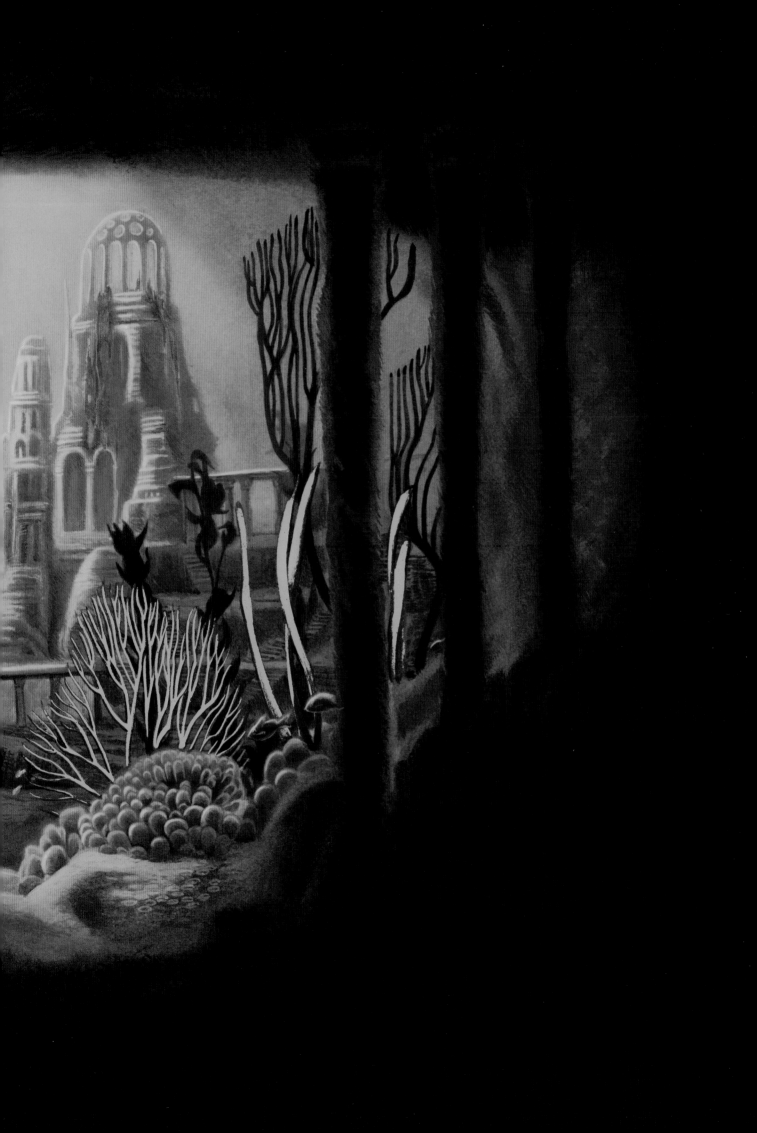

The Sea King had been a widower for many years, and his aged mother kept house for him. She was a very wise woman, and exceedingly proud of her high birth; on that account she wore twelve oysters on her tail; while others, also of high rank, were only allowed to wear six. She was, however, deserving of very great praise, especially for her care of the little sea-princesses, her grand-daughters. They were six beautiful children; but the youngest was the prettiest of them all; her skin was as clear and delicate as a rose-leaf, and her eyes as blue as the deepest sea; but, like all the others, she had no feet, and her body ended in a fish's tail. All day long they played in the great halls of the castle, or among the living flowers that grew out of the walls. The large amber windows were open, and the fish swam in, just as the swallows fly into our houses when we open the windows, excepting that the fishes swam up to the princesses, ate out of their hands, and allowed themselves to be stroked. Outside the castle there was a beautiful garden, in which grew bright red and dark blue flowers, and blossoms like flames of fire; the fruit glittered like gold, and the leaves and stems waved to and fro continually. The earth itself was the finest sand, but blue as the flame of burning sulphur. Over everything lay a peculiar blue radiance, as if it were surrounded by the air from above, through which the blue sky shone, instead of the dark depths of the sea. In calm weather the sun could be seen, looking like a purple flower, with the light streaming from the calyx.

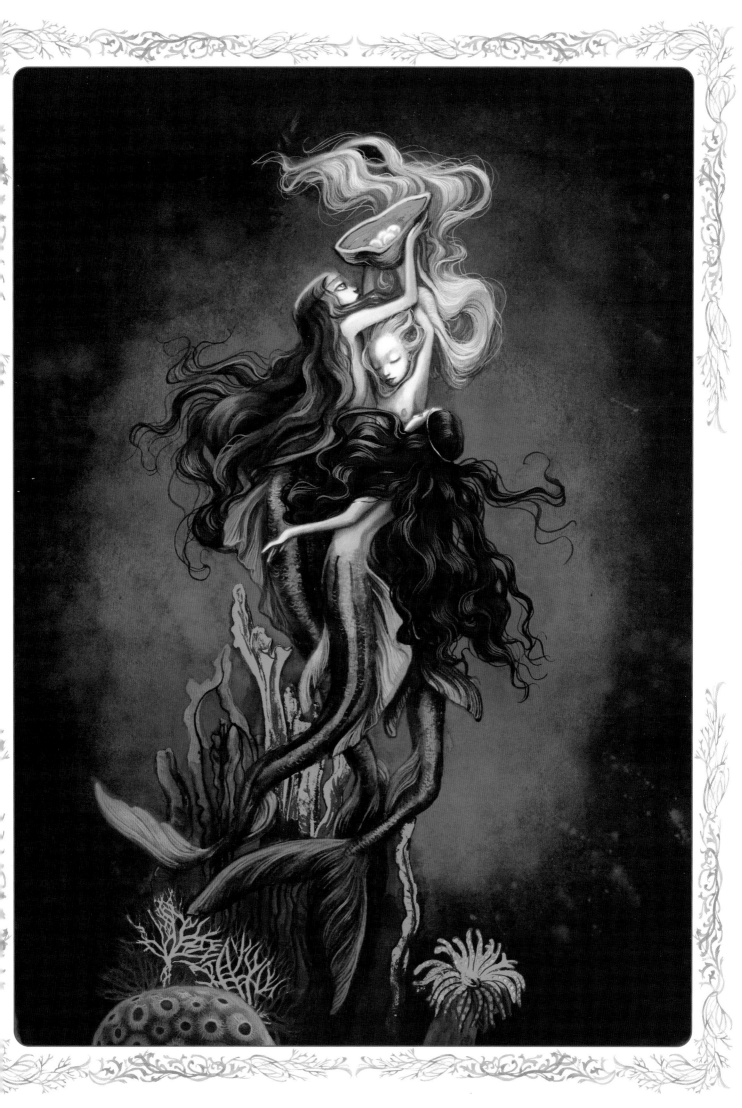

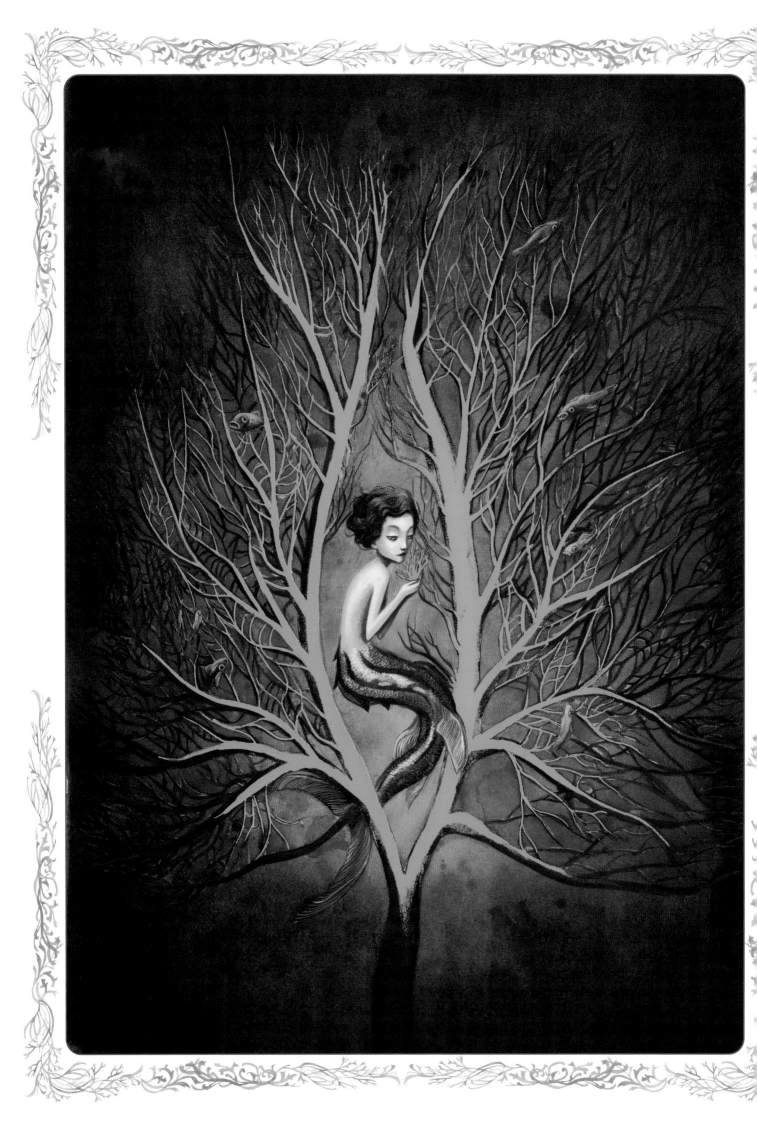

Each of the young princesses had a little plot of ground in the garden, where she might dig and plant as she pleased. One arranged her flower-bed into the form of a whale; another thought it better to make hers like the figure of a little mermaid; but that of the youngest was round like the sun, and contained flowers as red as his rays at sunset. She was a strange child, quiet and thoughtful; and while her sisters would be delighted with the wonderful things which they obtained from the wrecks of vessels, she cared for nothing but her pretty red flowers, like the sun, excepting a beautiful marble statue. It was the representation of a handsome boy, carved out of pure white stone, which had fallen to the bottom of the sea from a wreck. She planted by the statue a rose-colored weeping willow. It grew splendidly, and very soon hung its fresh branches over the statue, almost down to the blue sands. The shadow had a violet tint, and waved to and fro like the branches; it seemed as if the crown of the tree and the root were at play, and trying to kiss each other.

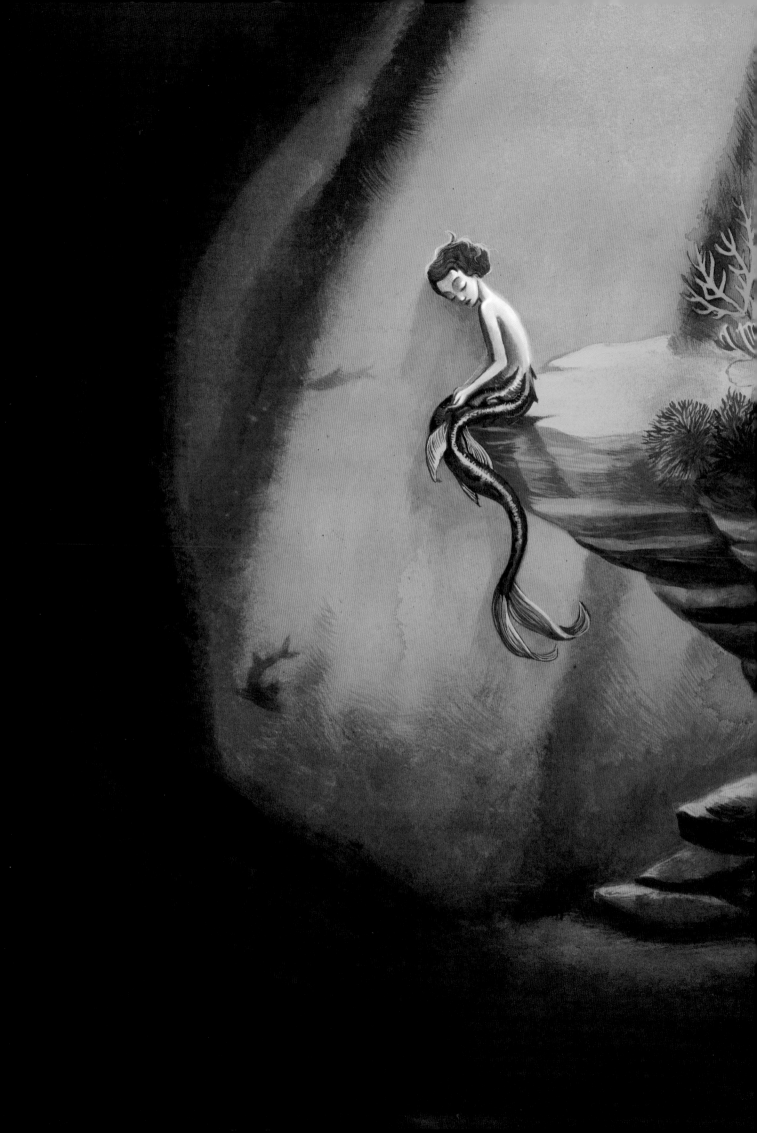

Nothing gave her so much pleasure as to hear about the world above the sea. She made her old grandmother tell her all she knew of the ships and of the towns, the people and the animals. To her it seemed most wonderful and beautiful to hear that the flowers of the land should have fragrance, and not those below the sea; that the trees of the forest should be green; and that the fishes among the trees could sing so sweetly, that it was quite a pleasure to hear them. Her grandmother called the little birds fishes, or she would not have understood her; for she had never seen birds.

"When you have reached your fifteenth year," said the grandmother, "you will have permission to rise up out of the sea, to sit on the rocks in the moonlight, while the great ships are sailing by; and then you will see both forests and towns."

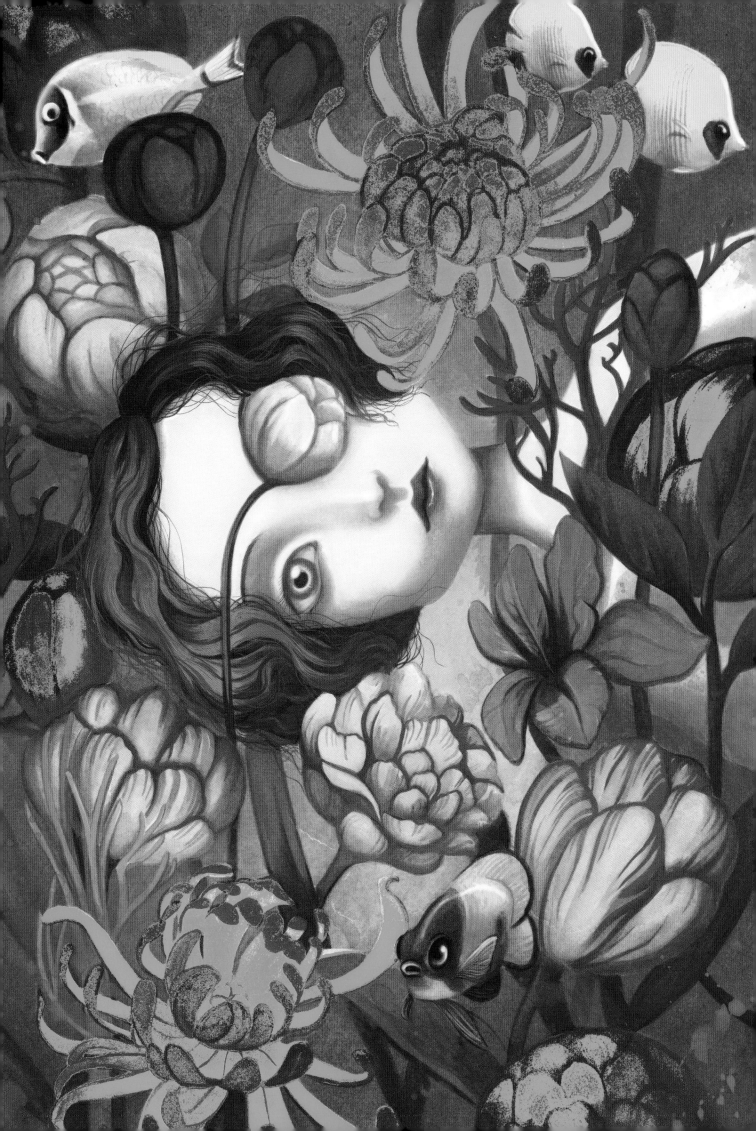

In the following year, one of the sisters would be fifteen: but as each was a year younger than the other, the youngest would have to wait five years before her turn came to rise up from the bottom of the ocean, and see the earth as we do. However, each promised to tell the others what she saw on her first visit, and what she thought the most beautiful; for their grandmother could not tell them enough; there were so many things on which they wanted information. None of them longed so much for her turn to come as the youngest, she who had the longest time to wait, and who was so quiet and thoughtful. Many nights she stood by the open window, looking up through the dark blue water, and watching the fish as they splashed about with their fins and tails. She could see the moon and stars shining faintly; but through the water they looked larger than they do to our eyes. When something like a black cloud passed between her and them, she knew that it was either a whale swimming over her head, or a ship full of human beings, who never imagined that a pretty little mermaid was standing beneath them, holding out her white hands towards the keel of their ship.

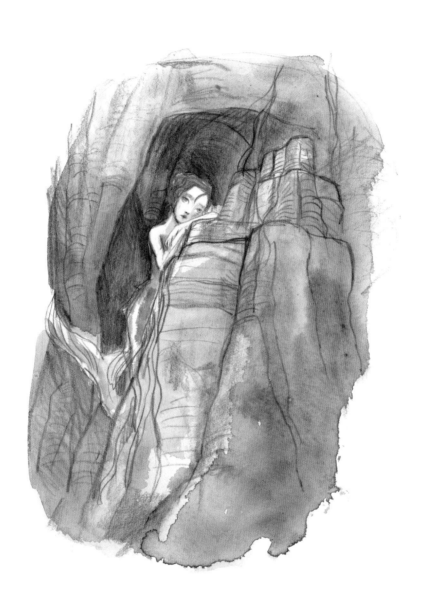

As soon as the eldest was fifteen, she was allowed to rise to the surface of the ocean. When she came back, she had hundreds of things to talk about; but the most beautiful, she said, was to lie in the moonlight, on a sandbank, in the quiet sea, near the coast, and to gaze on a large town nearby, where the lights were twinkling like hundreds of stars; to listen to the sounds of the music, the noise of carriages, and the voices of human beings, and then to hear the merry bells peal out from the church steeples; and because she could not go near to all those wonderful things, she longed for them more than ever. Oh, did not the youngest sister listen eagerly to all these descriptions? And afterwards, when she stood at the open window looking up through the dark blue water, she thought of the great city, with all its bustle and noise, and even fancied she could hear the sound of the church bells, down in the depths of the sea.

In another year the second sister received permission to rise to the surface of the water, and to swim about where she pleased. She rose just as the sun was setting, and this, she said, was the most beautiful sight of all. The whole sky looked like gold, while violet and rose-colored clouds, which she could not describe, floated over her; and, still more rapidly than the clouds, flew a large flock of wild swans towards the setting sun, looking like a long white veil across the sea. She also swam towards the sun; but it sunk into the waves, and the rosy tints faded from the clouds and from the sea.

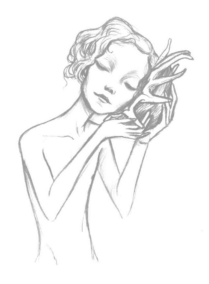

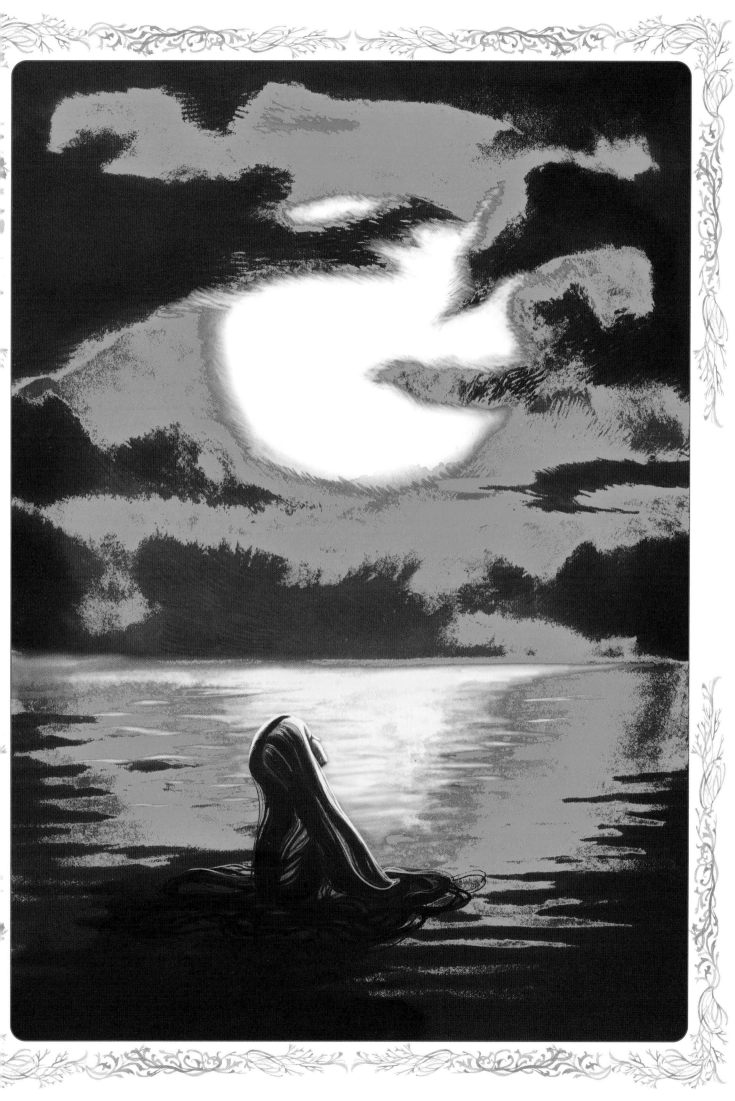

The third sister's turn followed; she was the boldest of them all, and she swam up a broad river that emptied itself into the sea. On the banks she saw green hills covered with beautiful vines; palaces and castles peeped out from amid the proud trees of the forest; she heard the birds singing, and the rays of the sun were so powerful that she was obliged often to dive down under the water to cool her burning face. In a narrow creek she found a whole troop of little human children, quite naked, and sporting about in the water; she wanted to play with them, but they fled in a great fright; and then a little black animal came to the water; it was a dog, but she did not know that, for she had never before seen one. This animal barked at her so terribly that she became frightened, and rushed back to the open sea. But she said she should never forget the beautiful forest, the green hills, and the pretty little children who could swim in the water, although they had not fish's tails.

The fourth sister was more timid; she remained in the midst of the sea, but she said it was quite as beautiful there as nearer the land. She could see for so many miles around her, and the sky above looked like a bell of glass. She had seen the ships, but at such a great distance that they looked like sea-gulls. The dolphins sported in the waves, and the great whales spouted water from their nostrils till it seemed as if a hundred fountains were playing in every direction.

The fifth sister's birthday occurred in the winter; so when her turn came, she saw what the others had not seen the first time they went up. The sea looked quite green, and large icebergs were floating about, each like a pearl, she said, but larger and loftier than the churches built by men. They were of the most singular shapes, and glittered like diamonds. She had seated herself upon one of the largest, and let the wind play with her long hair, and she remarked that all the ships sailed by rapidly, and steered as far away as they could from the iceberg, as if they were afraid of it. Towards evening, as the sun went down, dark clouds covered the sky, the thunder rolled and the lightning flashed, and the red light glowed on the icebergs as they rocked and tossed on the heaving sea. On all the ships the sails were reefed with fear and trembling, while she sat calmly on the floating iceberg, watching the blue lightning, as it darted its forked flashes into the sea.

When first the sisters had permission to rise to the surface, they were each delighted with the new and beautiful sights they saw; but now, as grown-up girls, they could go when they pleased, and they had become indifferent about it. They wished themselves back again in the water, and after a month had passed they said it was much more beautiful down below, and pleasanter to be at home. Yet often, in the evening hours, the five sisters would twine their arms round each other, and rise to the surface, in a row. They had more beautiful voices than any human being could have; and before the approach of a storm, and when they expected a ship would be lost, they swam before the vessel, and sang sweetly of the delights to be found in the depths of the sea, and begging the sailors not to fear if they sank to the bottom. But the sailors could not understand the song, they took it for the howling of the storm. And these things were never to be beautiful for them; for if the ship sank, the men were drowned, and their dead bodies alone reached the palace of the Sea King.

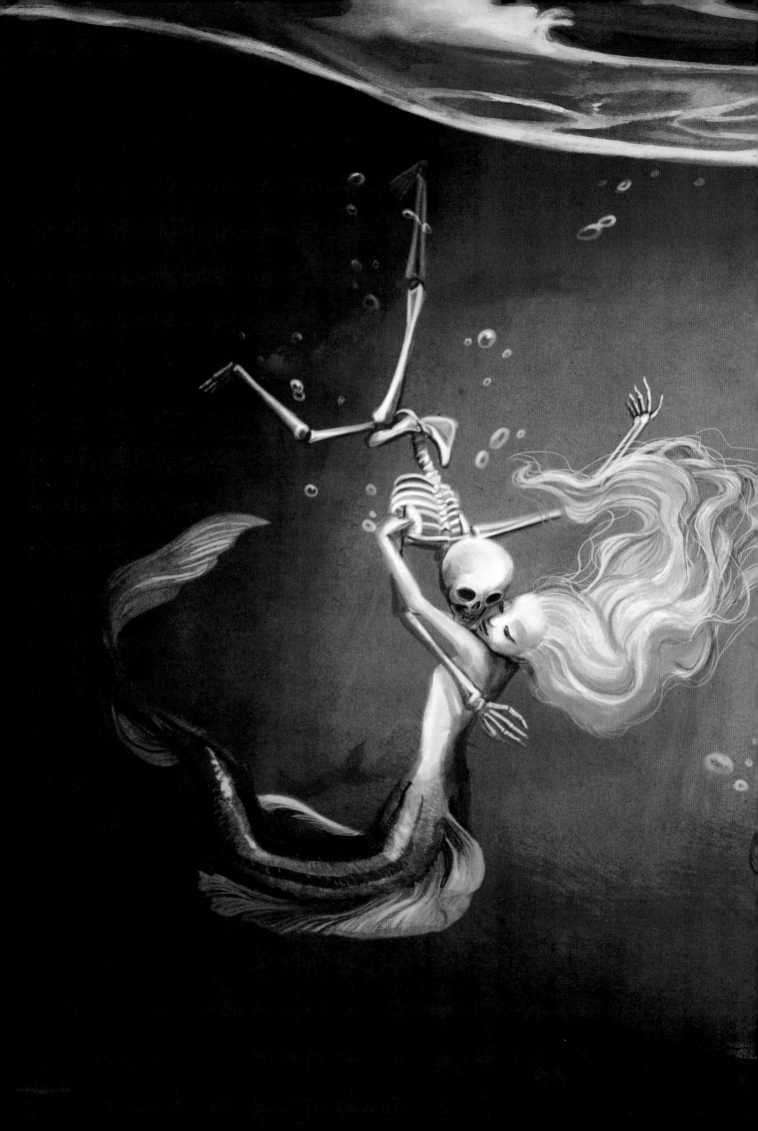

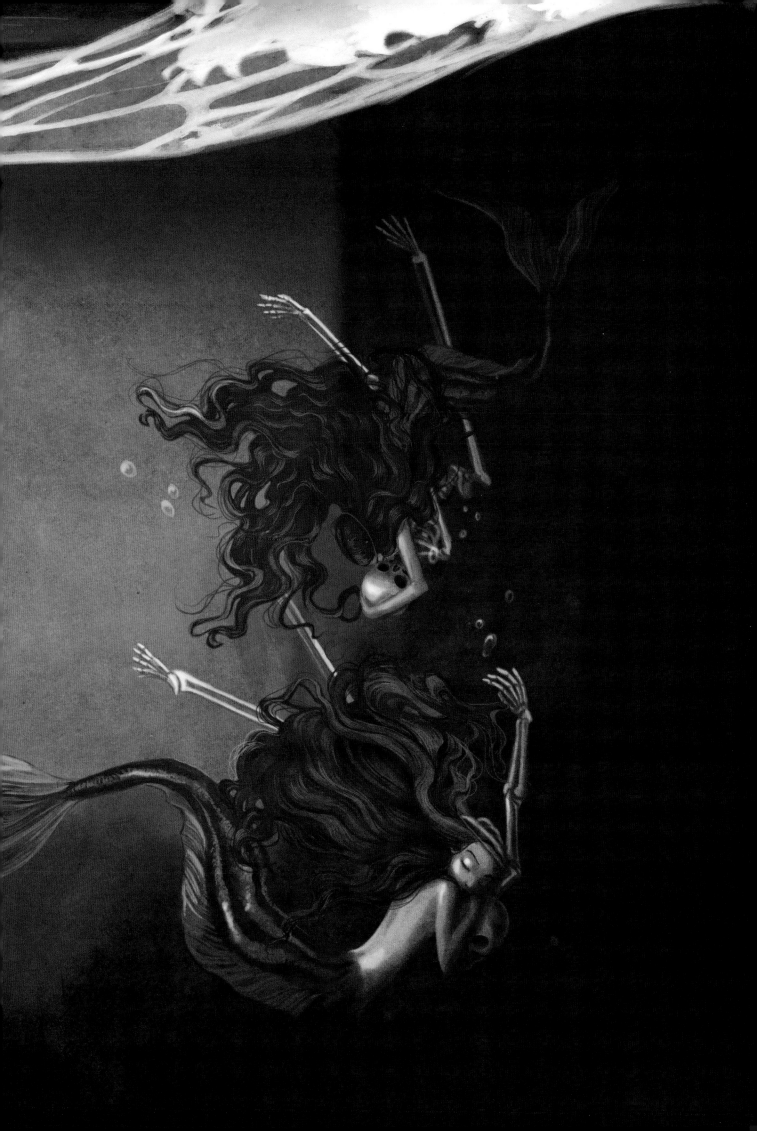

When the sisters rose, arm-in-arm, through the water in this way, their youngest sister would stand quite alone, looking after them, ready to cry, only that the mermaids have no tears, and therefore they suffer more. "Oh, were I but fifteen years old," said she: "I know that I shall love the world up there, and all the people who live in it."

At last she reached her fifteenth year. "Well, now, you are grown up," said the old dowager, her grandmother; "so you must let me adorn you like your other sisters;" and she placed a wreath of white lilies in her hair, and every flower leaf was half a pearl. Then the old lady ordered eight great oysters to attach themselves to the tail of the princess to show her high rank.

"But they hurt me so," said the little mermaid.

"Pride must suffer pain," replied the old lady. Oh, how gladly she would have shaken off all this grandeur, and laid aside the heavy wreath! The red flowers in her own garden would have suited her much better, but she could not help herself: so she said, "Farewell," and rose as lightly as a bubble to the surface of the water.

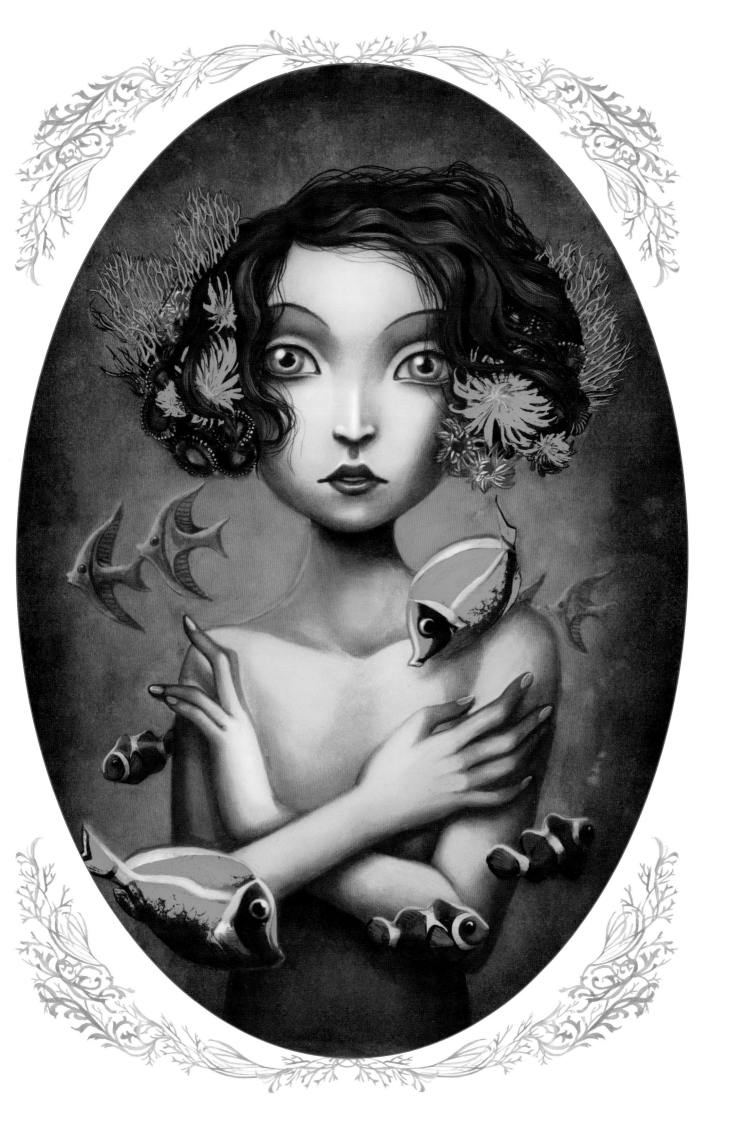

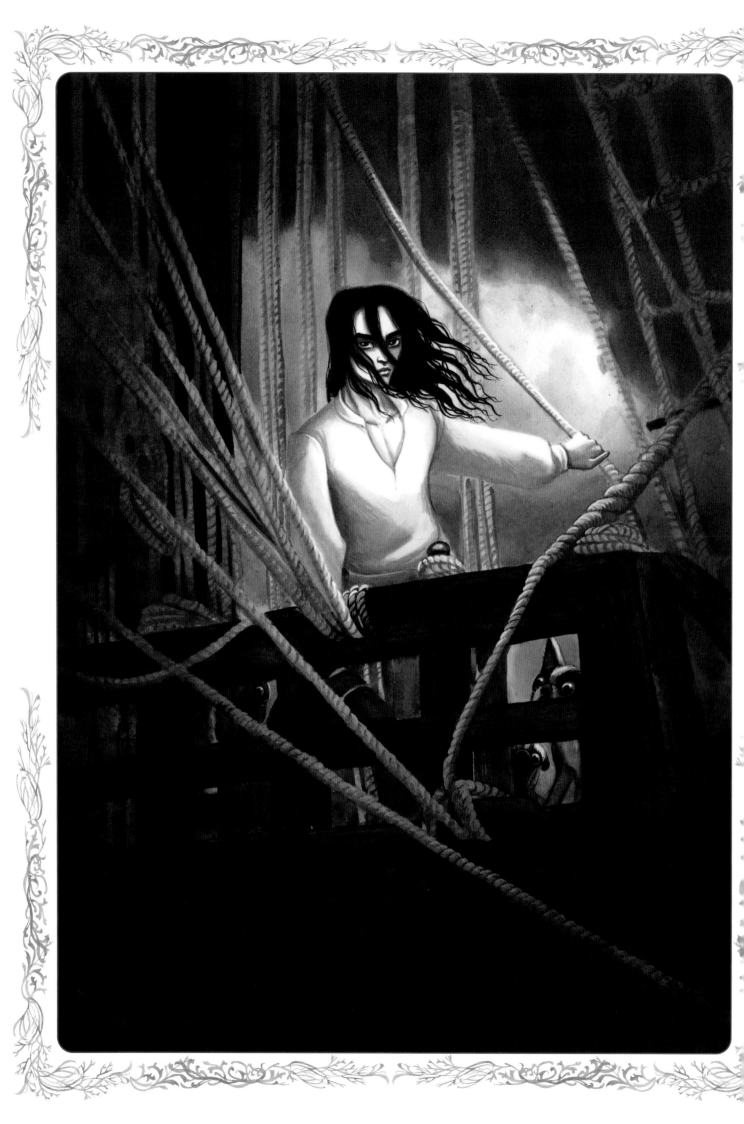

The sun had just set as she raised her head above the waves; but the clouds were tinted with crimson and gold, and through the glimmering twilight beamed the evening star in all its beauty. The sea was calm, and the air mild and fresh. A large ship, with three masts, lay becalmed on the water, with only one sail set; for not a breeze stiffed, and the sailors sat idle on deck or amongst the rigging. There was music and song on board; and, as darkness came on, a hundred colored lanterns were lighted, as if the flags of all nations waved in the air. The little mermaid swam close to the cabin windows; and now and then, as the waves lifted her up, she could look in through clear glass window-panes, and see a number of well-dressed people within. Among them was a young prince, the most beautiful of all, with large black eyes; he was sixteen years of age, and his birthday was being kept with much rejoic- ing. The sailors were dancing on deck, but when the prince came out of the cabin, more than a hundred rockets rose in the air, making it as bright as day. The little mermaid was so startled that she dived under water; and when she again stretched out her head, it appeared as if all the stars of heaven were falling around her, she had never seen such fireworks before. Great suns spurted fire about, splendid fireflies flew into the blue air, and everything was reflected in the clear, calm sea beneath. The ship itself was so brightly illuminated that all the people, and even the smallest rope, could be distinctly and plainly seen. And how handsome the young prince looked, as he pressed the hands of all present and smiled at them, while the music resounded through the clear night air.

It was very late; yet the little mermaid could not take her eyes from the ship, or from the beautiful prince. The colored lanterns had been extinguished, no more rockets rose in the air, and the cannon had ceased firing; but the sea became restless, and a moaning, grumbling sound could be heard beneath the waves: still the little mermaid remained by the cabin window, rocking up and down on the water, which enabled her to look in. After a while, the sails were quickly unfurled, and the noble ship continued her passage; but soon the waves rose higher, heavy clouds darkened the sky, and lightning appeared in the distance. A dreadful storm was approaching; once more the sails were reefed, and the great ship pursued her flying course over the raging sea. The waves rose mountains high, as if they would have overtopped the mast; but the ship dived like a swan between them, and then rose again on their lofty, foaming crests. To the little mermaid this appeared pleasant sport; not so to the sailors. At length the ship groaned and creaked; the thick planks gave way under the lashing of the sea as it broke over the deck; the mainmast snapped asunder like a reed; the ship lay over on her side; and the water rushed in. The little mermaid now perceived that the crew were in danger; even she herself was obliged to be careful to avoid the beams and planks of the wreck which lay scattered on the water.

At one moment it was so pitch dark that she could not see a single object, but a flash of lightning revealed the whole scene; she could see every one who had been on board excepting the prince; when the ship parted, she had seen him sink into the deep waves, and she was glad, for she thought he would now be with her; and then she remembered that human beings could not live in the water, so that when he got down to her father's palace he would be quite dead. But he must not die. So she swam about among the beams and planks which strewed the surface of the sea, forgetting that they could crush her to pieces. Then she dived deeply under the dark waters, rising and falling with the waves, till at length she managed to reach the young prince, who was fast losing the power of swimming in that stormy sea. His limbs were failing him, his beautiful eyes were closed, and he would have died had not the little mermaid come to his assistance. She held his head above the water, and let the waves drift them where they would.

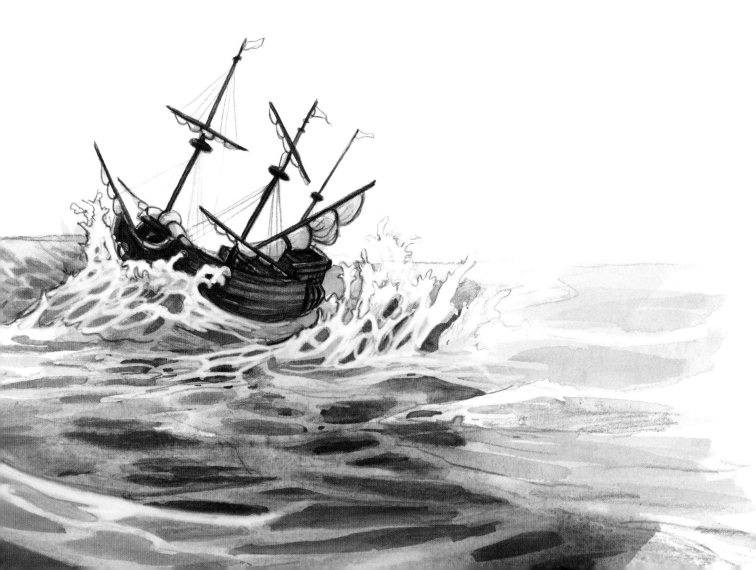

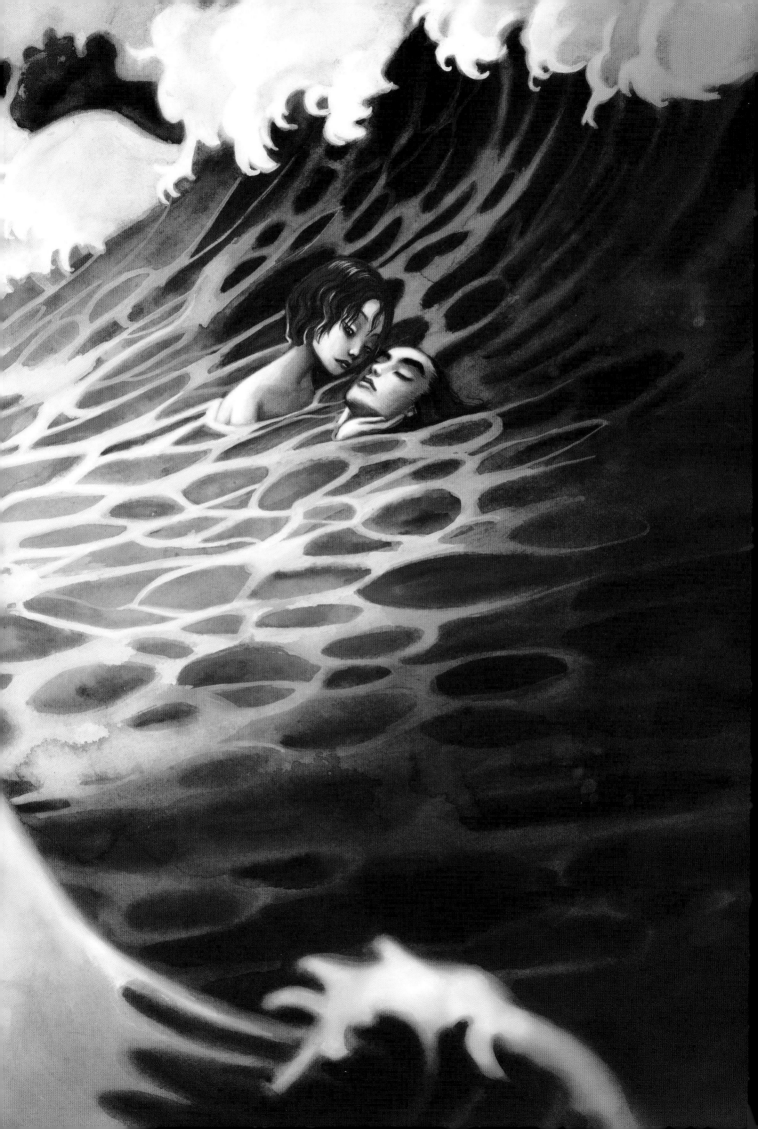

In the morning the storm had ceased; but of the ship not a single fragment could be seen. The sun rose up red and glowing from the water, and its beams brought back the hue of health to the prince's cheeks; but his eyes remained closed. The mermaid kissed his high, smooth forehead, and stroked back his wet hair; he seemed to her like the marble statue in her little garden, and she kissed him again, and wished that he might live. Presently they came in sight of land; she saw lofty blue mountains, on which the white snow rested as if a flock of swans were lying upon them. Near the coast were beautiful green forests, and close by stood a large building, whether a church or a convent she could not tell. Orange and citron trees grew in the garden, and before the door stood lofty palms. The sea here formed a little bay, in which the water was quite still, but very deep; so she swam with the handsome prince to the beach, which was covered with fine, white sand, and there she laid him in the warm sunshine, taking care to raise his head higher than his body. Then bells sounded in the large white building, and a number of young girls came into the garden. The little mermaid swam out farther from the shore and placed herself between some high rocks that rose out of the water; then she covered her head and neck with the foam of the sea so that her little face might not be seen, and watched to see what would become of the poor prince. She did not wait long before she saw a young girl approach the spot where he lay. She seemed frightened at first, but only for a moment; then she fetched a number of people, and the mermaid saw that the prince came to life again, and smiled upon those who stood round him. But to her he sent no smile; he knew not that she had saved him. This made her very unhappy, and when he was led away into the great building, she dived down sorrowfully into the water, and returned to her father's castle.

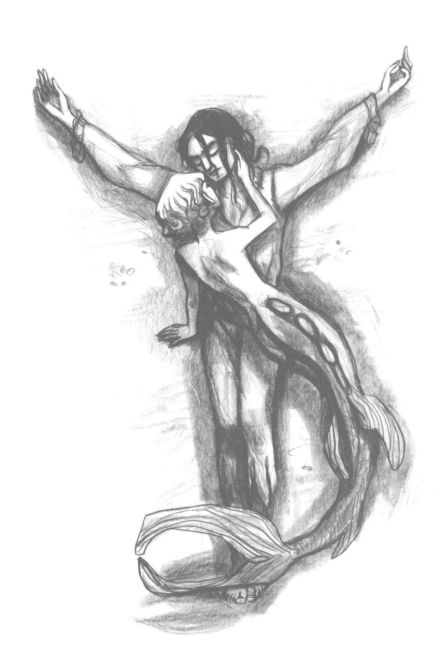

She had always been silent and thoughtful, and now she was more so than ever. Her sisters asked her what she had seen during her first visit to the surface of the water; but she would tell them nothing. Many an evening and morning did she rise to the place where she had left the prince. She saw the fruits in the garden ripen till they were gathered, the snow on the tops of the mountains melt away; but she never saw the prince, and therefore she returned home, always more sorrowful than before. It was her only comfort to sit in her own little garden, and fling her arm round the beautiful marble statue which was like the prince; but she gave up tending her flowers, and they grew in wild confusion over the paths, twining their long leaves and stems round the branches of the trees, so that the whole place became dark and gloomy. At length she could bear it no longer, and told one of her sisters all about it. Then the others heard the secret, and very soon it became known to two mermaids whose intimate friend happened to know who the prince was. She had also seen the festival on board ship, and she told them where the prince came from, and where his palace stood.

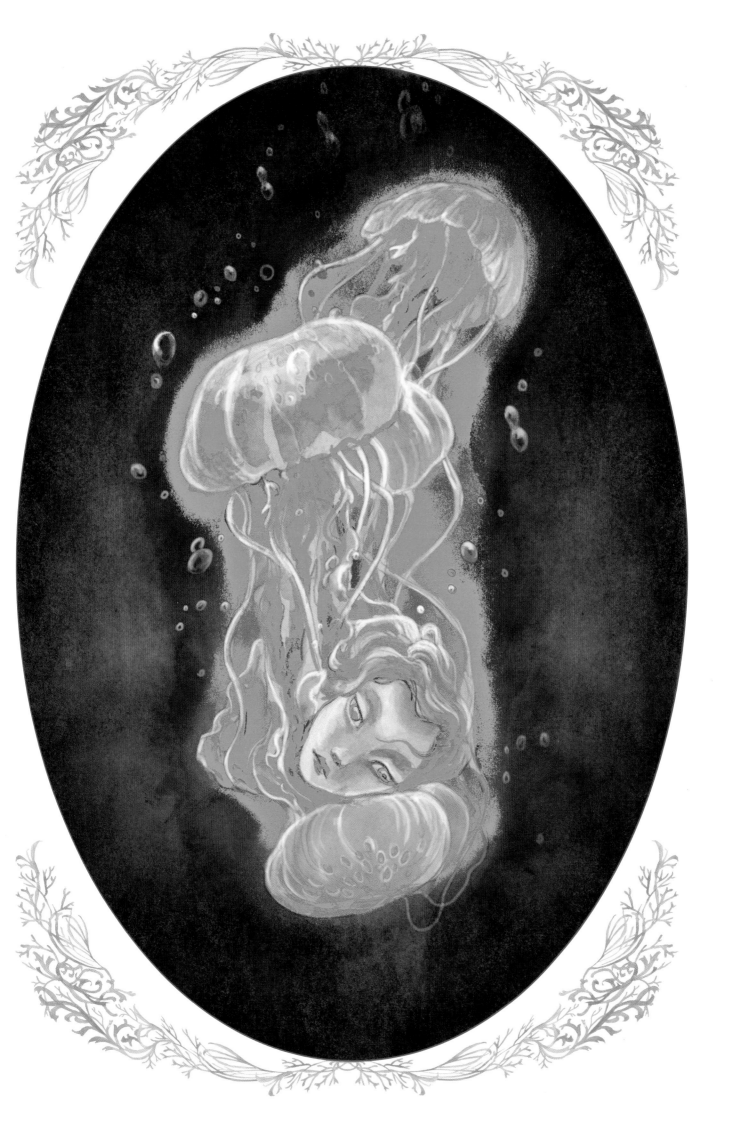

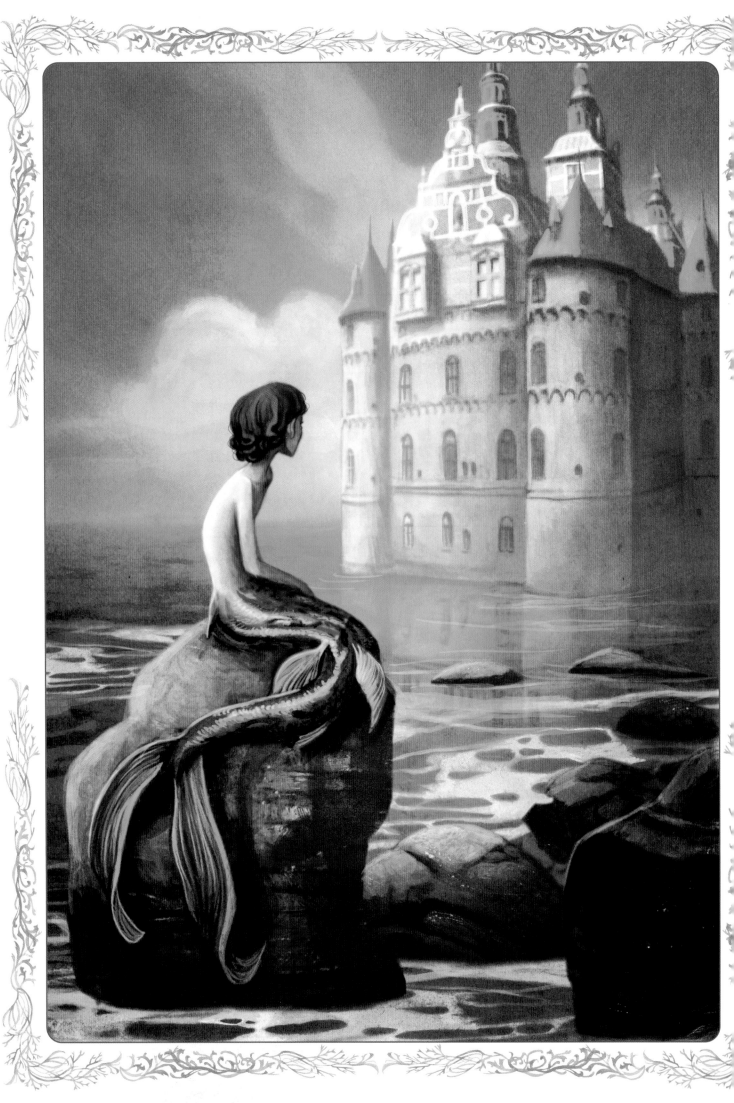

"Come, little sister," said the other princesses; then they entwined their arms and rose up in a long row to the surface of the water, close by the spot where they knew the prince's palace stood. It was built of bright yellow shining stone, with long flights of marble steps, one of which reached quite down to the sea. Splendid gilded cupolas rose over the roof, and between the pillars that surrounded the whole building stood life-like statues of marble. Through the clear crystal of the lofty windows could be seen noble rooms, with costly silk curtains and hangings of tapestry; while the walls were covered with beautiful paintings which were a pleasure to look at. In the centre of the largest saloon a fountain threw its sparkling jets high up into the glass cupola of the ceiling, through which the sun shone down upon the water and upon the beautiful plants growing round the basin of the fountain. Now that she knew where he lived, she spent many an evening and many a night on the water near the palace. She would swim much nearer the shore than any of the others ventured to do; indeed once she went quite up the narrow channel under the marble balcony, which threw a broad shadow on the water. Here she would sit and watch the young prince, who thought himself quite alone in the bright moonlight. She saw him many times of an evening sailing in a pleasant boat, with music playing and flags waving. She peeped out from among the green rushes, and if the wind caught her long silvery-white veil, those who saw it believed it to be a swan, spreading out its wings. On many a night, too, when the fishermen, with their torches, were out at sea, she heard them relate so many good things about the doings of the young prince, that she was glad she had saved his life when he had been tossed about half-dead on the waves. And she remembered that his head had rested on her bosom, and how heartily she had kissed him; but he knew nothing of all this, and could not even dream of her.

She grew more and more fond of human beings, and wished more and more to be able to wander about with those whose world seemed to be so much larger than her own. They could fly over the sea in ships, and mount the high hills which were far above the clouds; and the lands they possessed, their woods and their fields, stretched far away beyond the reach of her sight. There was so much that she wished to know, and her sisters were unable to answer all her questions. Then she applied to her old grandmother, who knew all about the upper world, which she very rightly called the lands above the sea.

"If human beings are not drowned," asked the little mermaid, "can they live forever? Do they never die as we do here in the sea?"

"Yes," replied the old lady, "they must also die, and their term of life is even shorter than ours. We sometimes live to three hundred years, but when we cease to exist here we only become the foam on the surface of the water, and we have not even a grave down here of those we love. We have not immortal souls, we shall never live again; but, like the green sea-weed, when once it has been cut off, we can never flourish more. Human beings, on the contrary, have a soul which lives forever, lives after the body has been turned to dust. It rises up through the clear, pure air beyond the glittering stars. As we rise out of the water, and behold all the land of the earth, so do they rise to unknown and glorious regions which we shall never see."

"Why have not we an immortal soul?" asked the little mermaid mournfully; "I would give gladly all the hundreds of years that I have to live, to be a human being only for one day, and to have the hope of knowing the happiness of that glorious world above the stars."

"You must not think of that," said the old woman; "we feel ourselves to be much happier and much better off than human beings."

"So I shall die," said the little mermaid, "and as the foam of the sea I shall be driven about never again to hear the music of the waves, or to see the pretty flowers nor the red sun. Is there anything I can do to win an immortal soul?"

"No," said the old woman, "unless a man were to love you so much that you were more to him than his father or mother; and if all his thoughts and all his love were fixed upon you, and the priest placed his right hand in yours, and he promised to be true to you here and hereafter, then his soul would glide into your body and you would obtain a share in the future happiness of mankind. He would give a soul to you and retain his own as well; but this can never happen. Your fish's tail, which amongst us is considered so beautiful, is thought on earth to be quite ugly; they do not know any better, and they think it necessary to have two stout props, which they call legs, in order to be handsome."

Then the little mermaid sighed, and looked sorrowfully at her fish's tail. "Let us be happy," said the old lady, "and dart and spring about during the three hundred years that we have to live, which is really quite long enough; after that we can rest ourselves all the better. This evening we are going to have a court ball."

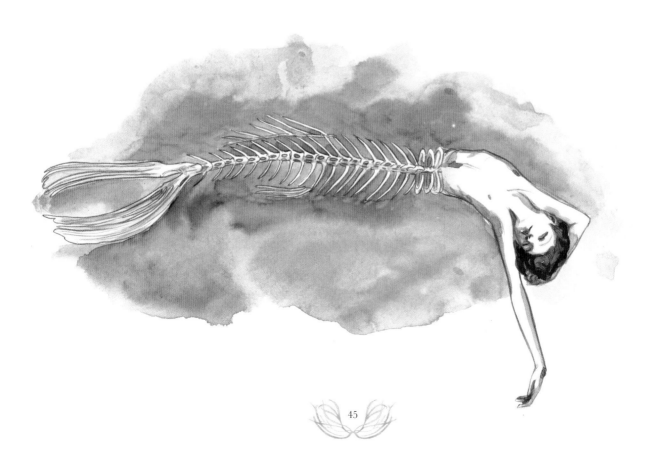

It is one of those splendid sights which we can never see on earth. The walls and the ceiling of the large ball-room were of thick, but transparent crystal. May hundreds of colossal shells, some of a deep red, others of a grass green, stood on each side in rows, with blue fire in them, which lighted up the whole saloon, and shone through the walls, so that the sea was also illuminated. Innumerable fishes, great and small, swam past the crystal walls; on some of them the scales glowed with a purple brilliancy, and on others they shone like silver and gold. Through the halls flowed a broad stream, and in it danced the mermen and the mermaids to the music of their own sweet singing. No one on earth has such a lovely voice as theirs. The little mermaid sang more sweetly than them all. The whole court applauded her with hands and tails; and for a moment her heart felt quite gay, for she knew she had the loveliest voice of any on earth or in the sea. But she soon thought again of the world above her, for she could not forget the charming prince, nor her sorrow that she had not an immortal soul like his; therefore she crept away silently out of her father's palace, and while everything within was gladness and song, she sat in her own little garden sorrowful and alone. Then she heard the bugle sounding through the water, and thought—"He is certainly sailing above, he on whom my wishes depend, and in whose hands I should like to place the happiness of my life. I will venture all for him, and to win an immortal soul, while my sisters are dancing in my father's palace, I will go to the sea witch, of whom I have always been so much afraid, but she can give me counsel and help."

And then the little mermaid went out from her garden, and took the road to the foaming whirlpools, behind which the sorceress lived. She had never been that way before: neither flowers nor grass grew there; nothing but bare, gray, sandy ground stretched out to the whirlpool, where the water, like foaming mill-wheels, whirled round everything that it seized, and cast it into the fathomless deep. Through the midst of these crushing whirlpools the little mermaid was obliged to pass, to reach the dominions of the sea witch; and also for a long distance the only road lay right across a quantity of warm, bubbling mire, called by the witch her turfmoor. Beyond this stood her house, in the centre of a strange forest, in which all the trees and flowers were polypi, half animals and half plants; they looked like serpents with a hundred heads growing out of the ground. The branches were long slimy arms, with fingers like flexible worms, moving limb after limb from the root to the top. All that could be reached in the sea they seized upon, and held fast, so that it never escaped from their clutches. The little mermaid was so alarmed at what she saw, that she stood still, and her heart beat with fear, and she was very nearly turning back; but she thought of the prince, and of the human soul for which she longed, and her courage returned. She fastened her long flowing hair round her head, so that the polypi might not seize hold of it. She laid her hands together across her bosom, and then she darted forward as a fish shoots through the water, between the supple arms and fingers of the ugly polypi, which were stretched out on each side of her. She saw that each held in its grasp something it had seized with its numerous little arms, as if they were iron bands. The white skeletons of human beings who had perished at sea, and had sunk down into the deep waters, skeletons of land animals, oars, rudders, and chests of ships were lying tightly grasped by their clinging arms; even a little mermaid, whom they had caught and strangled; and this seemed the most shocking of all to the little princess.

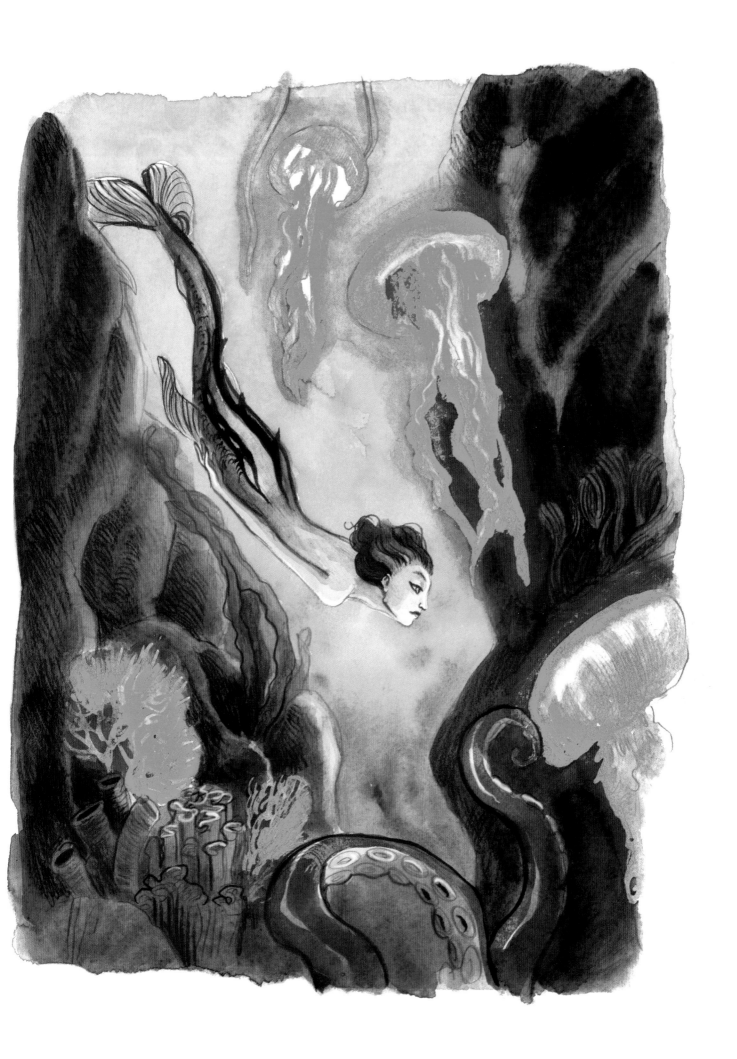

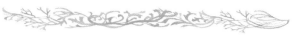 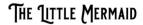

She now came to a space of marshy ground in the wood, where large, fat water-snakes were rolling in the mire, and showing their ugly, drab-colored bodies. In the midst of this spot stood a house, built with the bones of shipwrecked human beings. There sat the sea witch, allowing a toad to eat from her mouth, just as people sometimes feed a canary with a piece of sugar. She called the ugly water-snakes her little chickens, and allowed them to crawl all over her bosom.

"I know what you want," said the sea witch; "it is very stupid of you, but you shall have your way, and it will bring you to sorrow, my pretty princess. You want to get rid of your fish's tail, and to have two supports instead of it, like human beings on earth, so that the young prince may fall in love with you, and that you may have an immortal soul." And then the witch laughed so loud and disgustingly, that the toad and the snakes fell to the ground, and lay there wriggling about. "You are but just in time," said the witch; "for after sunrise to-morrow I should not be able to help you till the end of another year. I will prepare a draught for you, with which you must swim to land tomorrow before sunrise, and sit down on the shore and drink it. Your tail will then disappear, and shrink up into what mankind calls legs, and you will feel great pain, as if a sword were passing through you. But all who see you will say that you are the prettiest little human being they ever saw. You will still have the same floating gracefulness of movement, and no dancer will ever tread so lightly; but at every step you take it will feel as if you were treading upon sharp knives, and that the blood must flow. If you will bear all this, I will help you."

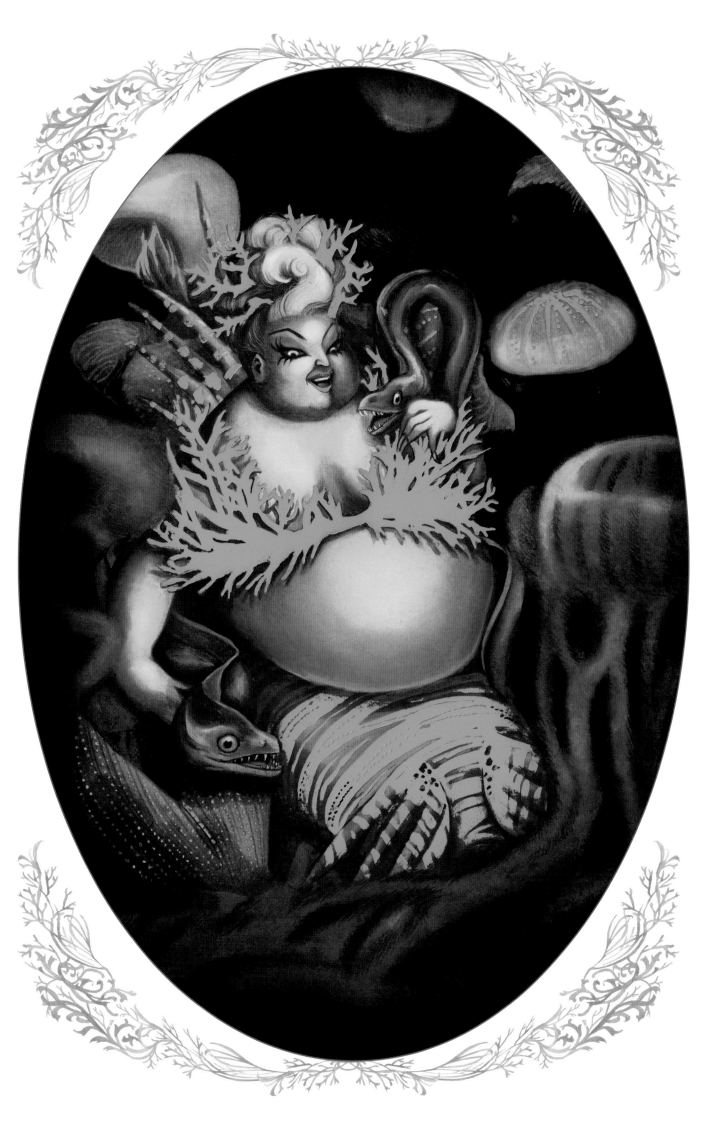

"Yes, I will," said the little princess in a trembling voice, as she thought of the prince and the immortal soul.

"But think again," said the witch; "for when once your shape has become like a human being, you can no more be a mermaid. You will never return through the water to your sisters, or to your father's palace again; and if you do not win the love of the prince, so that he is willing to forget his father and mother for your sake, and to love you with his whole soul, and allow the priest to join your hands that you may be man and wife, then you will never have an immortal soul. The first morning after he marries another your heart will break, and you will become foam on the crest of the waves."

"I will do it," said the little mermaid, and she became pale as death.

"But I must be paid also," said the witch, "and it is not a trifle that I ask. You have the sweetest voice of any who dwell here in the depths of the sea, and you believe that you will be able to charm the prince with it also, but this voice you must give to me; the best thing you possess will I have for the price of my draught. My own blood must be mixed with it, that it may be as sharp as a two-edged sword."

"But if you take away my voice," said the little mermaid, "what is left for me?"

"Your beautiful form, your graceful walk, and your expressive eyes; surely with these you can enchain a man's heart. Well, have you lost your courage? Put out your little tongue that I may cut it off as my payment; then you shall have the powerful draught."

"It shall be," said the little mermaid.

Then the witch placed her cauldron on the fire, to prepare the magic draught.

"Cleanliness is a good thing," said she, scouring the vessel with snakes, which she had tied together in a large knot; then she pricked herself in the breast, and let the black blood drop into it. The steam that rose formed itself into such horrible shapes that no one could look at them without fear. Every moment the witch threw something else into the vessel, and when it began to boil, the sound was like the weeping of a crocodile. When at last the magic draught was ready, it looked like the clearest water. "There it is for you," said the witch. Then she cut off the mermaid's tongue, so that she became dumb, and would never again speak or sing. "If the polypi should seize hold of you as you return through the wood," said the witch, "throw over them a few drops of the potion, and their fingers will be torn into a thousand pieces." But the little mermaid had no occasion to do this, for the polypi sprang back in terror when they caught sight of the glittering draught, which shone in her hand like a twinkling star.

So she passed quickly through the wood and the marsh, and between the rushing whirlpools. She saw that in her father's palace the torches in the ballroom were extinguished, and all within asleep; but she did not venture to go in to them, for now she was dumb and going to leave them forever, she felt as if her heart would break.

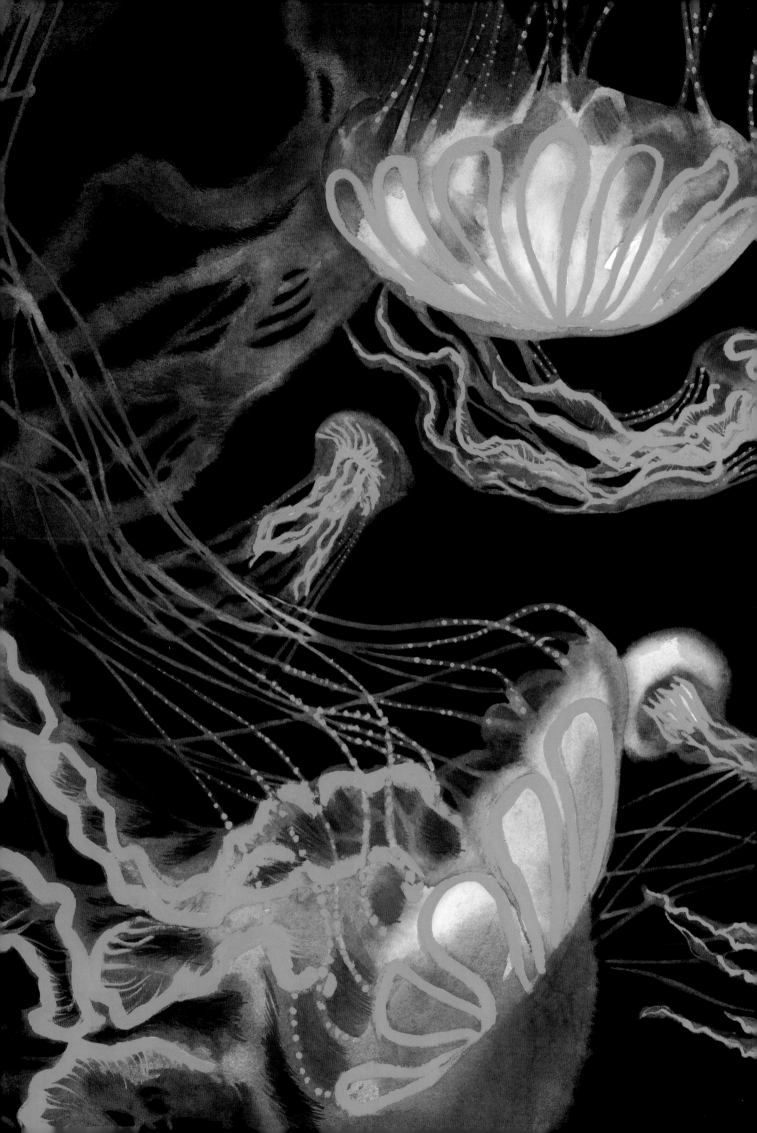

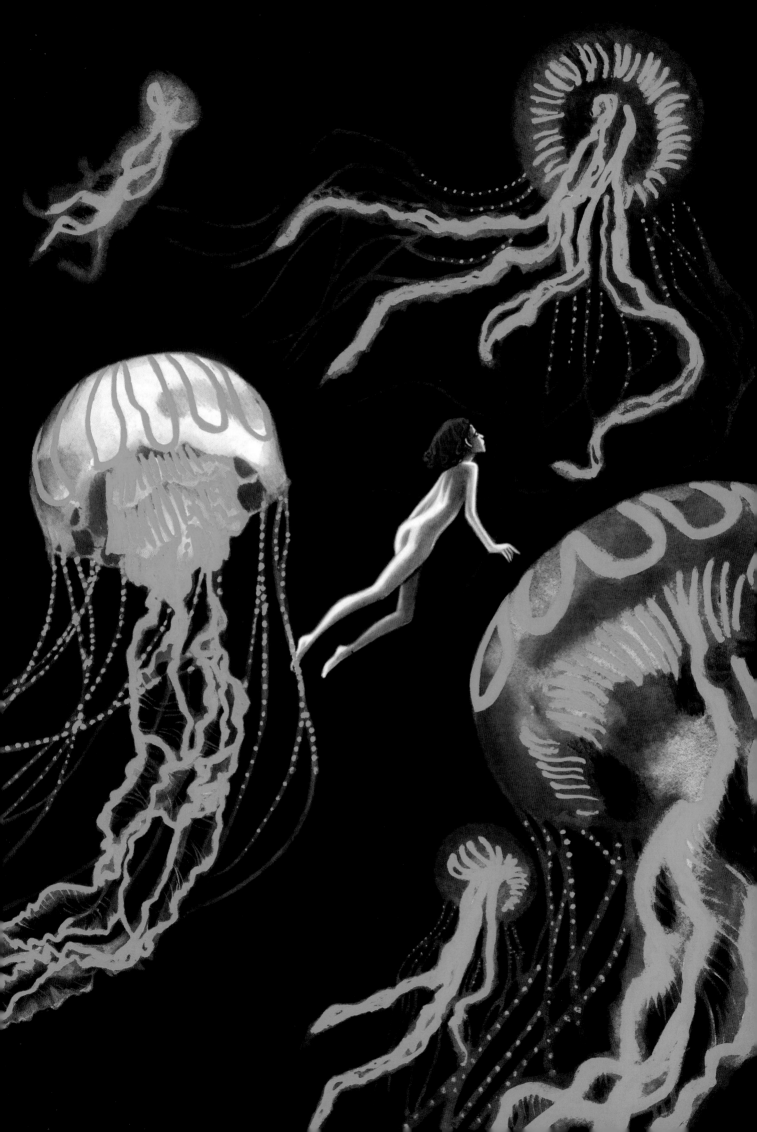

She stole into the garden, took a flower from the flower-beds of each of her sisters, kissed her hand a thousand times towards the palace, and then rose up through the dark blue waters. The sun had not risen when she came in sight of the prince's palace, and approached the beautiful marble steps, but the moon shone clear and bright. Then the little mermaid drank the magic draught, and it seemed as if a two-edged sword went through her delicate body: she fell into a swoon, and lay like one dead. When the sun arose and shone over the sea, she recovered, and felt a sharp pain; but just before her stood the handsome young prince. He fixed his coal-black eyes upon her so earnestly that she cast down her own, and then became aware that her fish's tail was gone, and that she had as pretty a pair of white legs and tiny feet as any little maiden could have; but she had no clothes, so she wrapped herself in her long, thick hair. The prince asked her who she was, and where she came from, and she looked at him mildly and sorrowfully with her deep blue eyes; but she could not speak. Every step she took was as the witch had said it would be, she felt as if treading upon the points of needles or sharp knives; but she bore it willingly, and stepped as lightly by the prince's side as a soap-bubble, so that he and all who saw her wondered at her graceful-swaying movements. She was very soon arrayed in costly robes of silk and muslin, and was the most beautiful creature in the palace; but she was dumb, and could neither speak nor sing.

Beautiful female slaves, dressed in silk and gold, stepped forward and sang before the prince and his royal parents: one sang better than all the others, and the prince clapped his hands and smiled at her. This was great sorrow to the little mermaid; she knew how much more sweetly she herself could sing once, and she thought, "Oh if he could only know that! I have given away my voice forever, to be with him."

The slaves next performed some pretty fairy-like dances, to the sound of beautiful music. Then the little mermaid raised her lovely white arms, stood on the tips of her toes, and glided over the floor, and danced as no one yet had been able to dance. At each moment her beauty became more revealed, and her expressive eyes appealed more directly to the heart than the songs of the slaves. Every one was enchanted, especially the prince, who called her his little foundling; and she danced again quite readily, to please him, though each time her foot touched the floor it seemed as if she trod on sharp knives.

The prince said she should remain with him always, and she received permission to sleep at his door, on a velvet cushion. He had a page's dress made for her, that she might accompany him on horseback. They rode together through the sweet-scented woods, where the green boughs touched their shoulders, and the little birds sang among the fresh leaves.

She climbed with the prince to the tops of high mountains; and although her tender feet bled so that even her steps were marked, she only laughed, and followed him till they could see the clouds beneath them looking like a flock of birds travelling to distant lands. While at the prince's palace, and when all the household were asleep, she would go and sit on the broad marble steps; for it eased her burning feet to bathe them in the cold sea-water; and then she thought of all those below in the deep.

Once during the night her sisters came up arm-in-arm, singing sorrowfully, as they floated on the water. She beckoned to them, and then they recognized her, and told her how she had grieved them. After that, they came to the same place every night; and once she saw in the distance her old grandmother, who had not been to the surface of the sea for many years, and the old Sea King, her father, with his crown on his head. They stretched out their hands towards her, but they did not venture so near the land as her sisters did.

As the days passed, she loved the prince more fondly, and he loved her as he would love a little child, but it never came into his head to make her his wife; yet, unless he married her, she could not receive an immortal soul; and, on the morning after his marriage with another, she would dissolve into the foam of the sea.

"Do you not love me the best of them all?" the eyes of the little mermaid seemed to say, when he took her in his arms, and kissed her fair forehead.

"Yes, you are dear to me," said the prince; "for you have the best heart, and you are the most devoted to me; you are like a young maiden whom I once saw, but whom I shall never meet again. I was in a ship that was wrecked, and the waves cast me ashore near a holy temple, where several young maidens performed the service. The youngest of them found me on the shore, and saved my life. I saw her but twice, and she is the only one in the world whom I could love; but you are like her, and you have almost driven her image out of my mind. She belongs to the holy temple, and my good fortune has sent you to me instead of her; and we will never part."

"Ah, he knows not that it was I who saved his life," thought the little mermaid. "I carried him over the sea to the wood where the temple stands: I sat beneath the foam, and watched till the human beings came to help him. I saw the pretty maiden that he loves better than he loves me;" and the mermaid sighed deeply, but she could not shed tears. "He says the maiden belongs to the holy temple, therefore she will never return to the world. They will meet no more: while I am by his side, and see him every day. I will take care of him, and love him, and give up my life for his sake."

Very soon it was said that the prince must marry, and that the beautiful daughter of a neighboring king would be his wife, for a fine ship was being fitted out. Although the prince gave out that he merely intended to pay a visit to the king, it was generally supposed that he really went to see his daughter. A great company were to go with him. The little mermaid smiled, and shook her head. She knew the prince's thoughts better than any of the others.

"I must travel," he had said to her; "I must see this beautiful princess; my parents desire it; but they will not oblige me to bring her home as my bride. I cannot love her; she is not like the beautiful maiden in the temple, whom you resemble. If I were forced to choose a bride, I would rather choose you, my dumb foundling, with those expressive eyes." And then he kissed her rosy mouth, played with her long waving hair, and laid his head on her heart, while she dreamed of human happiness and an immortal soul.

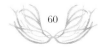

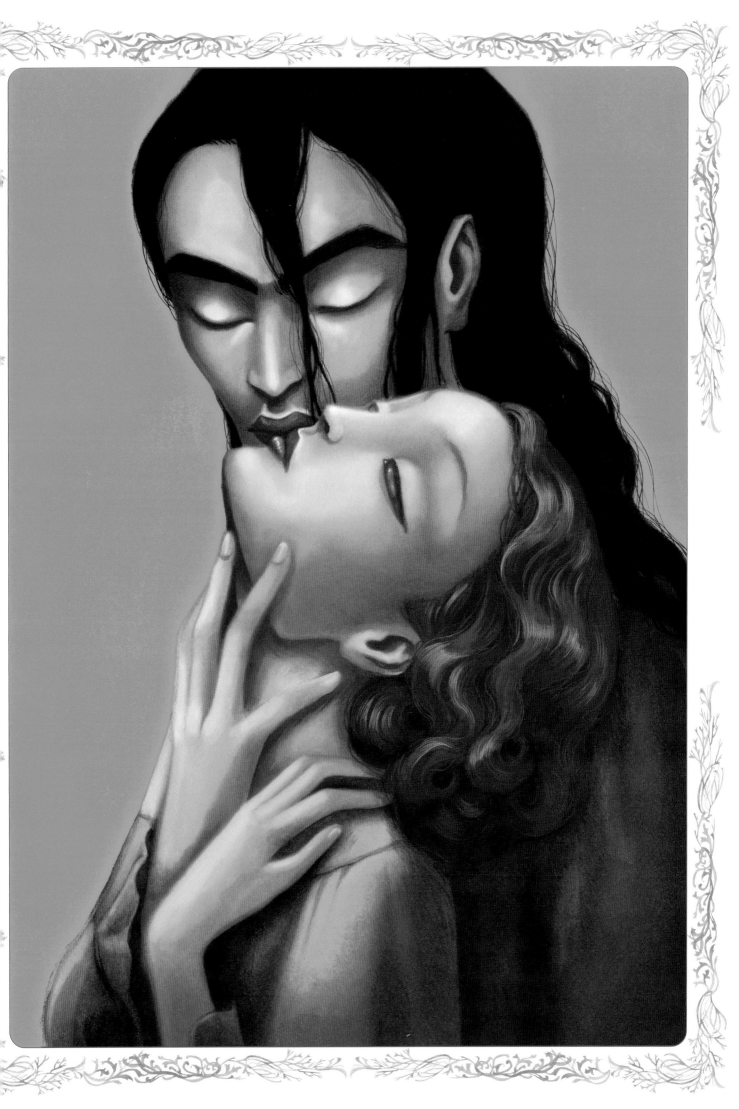

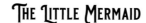

"You are not afraid of the sea, my dumb child," said he, as they stood on the deck of the noble ship which was to carry them to the country of the neighboring king. And then he told her of storm and of calm, of strange fishes in the deep beneath them, and of what the divers had seen there; and she smiled at his descriptions, for she knew better than any one what wonders were at the bottom of the sea.

In the moonlight, when all on board were asleep, excepting the man at the helm, who was steering, she sat on the deck, gazing down through the clear water. She thought she could distinguish her father's castle, and upon it her aged grandmother, with the silver crown on her head, looking through the rushing tide at the keel of the vessel. Then her sisters came up on the waves, and gazed at her mournfully, wringing their white hands. She beckoned to them, and smiled, and wanted to tell them how happy and well off she was; but the cabin-boy approached, and when her sisters dived down he thought it was only the foam of the sea which he saw.

The next morning the ship sailed into the harbor of a beautiful town belonging to the king whom the prince was going to visit. The church bells were ringing, and from the high towers sounded a flourish of trumpets; and soldiers, with flying colors and glittering bayonets, lined the rocks through which they passed. Every day was a festival; balls and entertainments followed one another.

But the princess had not yet appeared. People said that she was being brought up and educated in a religious house, where she was learning every royal virtue. At last she came. Then the little mermaid, who was very anxious to see whether she was really beautiful, was obliged to acknowledge that she had never seen a more perfect vision of beauty. Her skin was delicately fair, and beneath her long dark eye-lashes her laughing blue eyes shone with truth and purity.

"It was you," said the prince, "who saved my life when I lay dead on the beach," and he folded his blushing bride in his arms. "Oh, I am too happy," said he to the little mermaid; "my fondest hopes are all fulfilled. You will rejoice at my happiness; for your devotion to me is great and sincere."

The little mermaid kissed his hand, and felt as if her heart were already broken. His wedding morning would bring death to her, and she would change into the foam of the sea. All the church bells rung, and the heralds rode about the town proclaiming the betrothal.

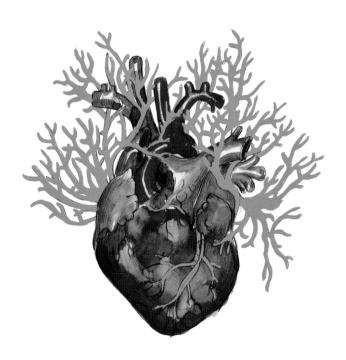

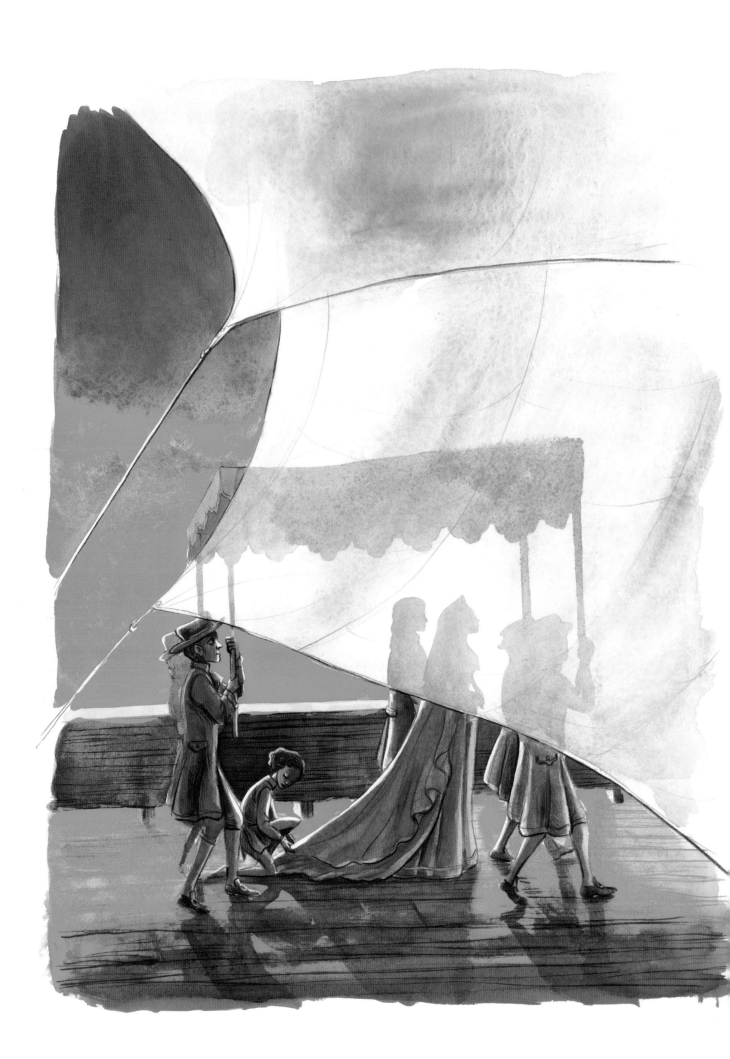

Perfumed oil was burning in costly silver lamps on every altar. The priests waved the censers, while the bride and bridegroom joined their hands and received the blessing of the bishop. The little mermaid, dressed in silk and gold, held up the bride's train; but her ears heard nothing of the festive music, and her eyes saw not the holy ceremony; she thought of the night of death which was coming to her, and of all she had lost in the world. On the same evening the bride and bridegroom went on board ship; cannons were roaring, flags waving, and in the centre of the ship a costly tent of purple and gold had been erected. It contained elegant couches, for the reception of the bridal pair during the night. The ship, with swelling sails and a favorable wind, glided away smoothly and lightly over the calm sea. When it grew dark a number of colored lamps were lit, and the sailors danced merrily on the deck. The little mermaid could not help thinking of her first rising out of the sea, when she had seen similar festivities and joys; and she joined in the dance, poised herself in the air as a swallow when he pursues his prey, and all present cheered her with wonder. She had never danced so elegantly before. Her tender feet felt as if cut with sharp knives, but she cared not for it; a sharper pang had pierced through her heart. She knew this was the last evening she should ever see the prince, for whom she had forsaken her kindred and her home; she had given up her beautiful voice, and suffered unheard-of pain daily for him, while he knew nothing of it. This was the last evening that she would breathe the same air with him, or gaze on the starry sky and the deep sea; an eternal night, without a thought or a dream, awaited her: she had no soul and now she could never win one. All was joy and gayety on board ship till long after midnight; she laughed and danced with the rest, while the thoughts of death were in her heart. The prince kissed his beautiful bride, while she played with his raven hair, till they went arm-in-arm to rest in the splendid tent.

Then all became still on board the ship; the helmsman, alone awake, stood at the helm. The little mermaid leaned her white arms on the edge of the vessel, and looked towards the east for the first blush of morning, for that first ray of dawn that would bring her death. She saw her sisters rising out of the flood: they were as pale as herself; but their long beautiful hair waved no more in the wind, and had been cut off.

"We have given our hair to the witch," said they, "to obtain help for you, that you may not die to-night. She has given us a knife: here it is, see it is very sharp. Before the sun rises you must plunge it into the heart of the prince; when the warm blood falls upon your feet they will grow together again, and form into a fish's tail, and you will be once more a mermaid, and return to us to live out your three hundred years before you die and change into the salt sea foam. Haste, then; he or you must die before sunrise. Our old grandmother moans so for you, that her white hair is falling off from sorrow, as ours fell under the witch's scissors. Kill the prince and come back; hasten: do you not see the first red streaks in the sky? In a few minutes the sun will rise, and you must die." And then they sighed deeply and mournfully, and sank down beneath the waves.

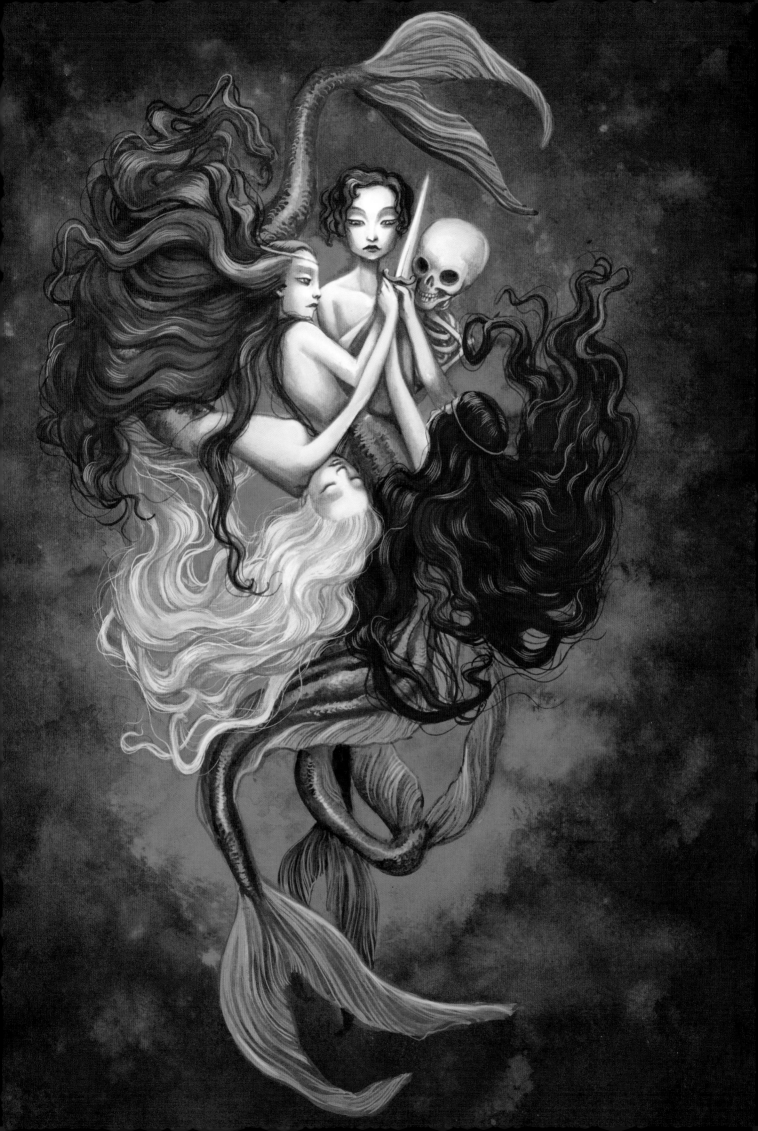

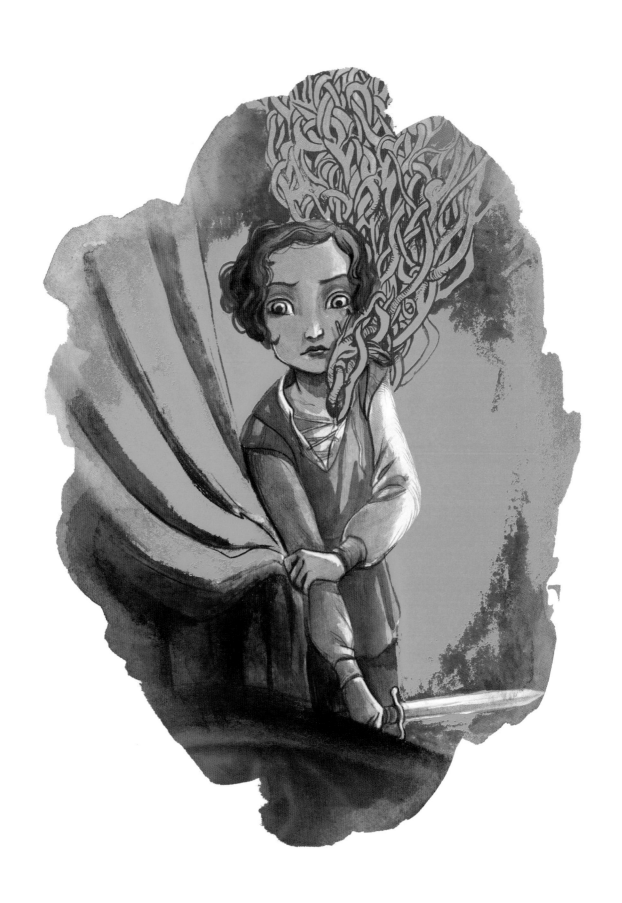

The little mermaid drew back the crimson curtain of the tent, and beheld the fair bride with her head resting on the prince's breast. She bent down and kissed his fair brow, then looked at the sky on which the rosy dawn grew brighter and brighter; then she glanced at the sharp knife, and again fixed her eyes on the prince, who whispered the name of his bride in his dreams. She was in his thoughts, and the knife trembled in the hand of the little mermaid: then she flung it far away from her into the waves; the water turned red where it fell, and the drops that spurted up looked like blood.

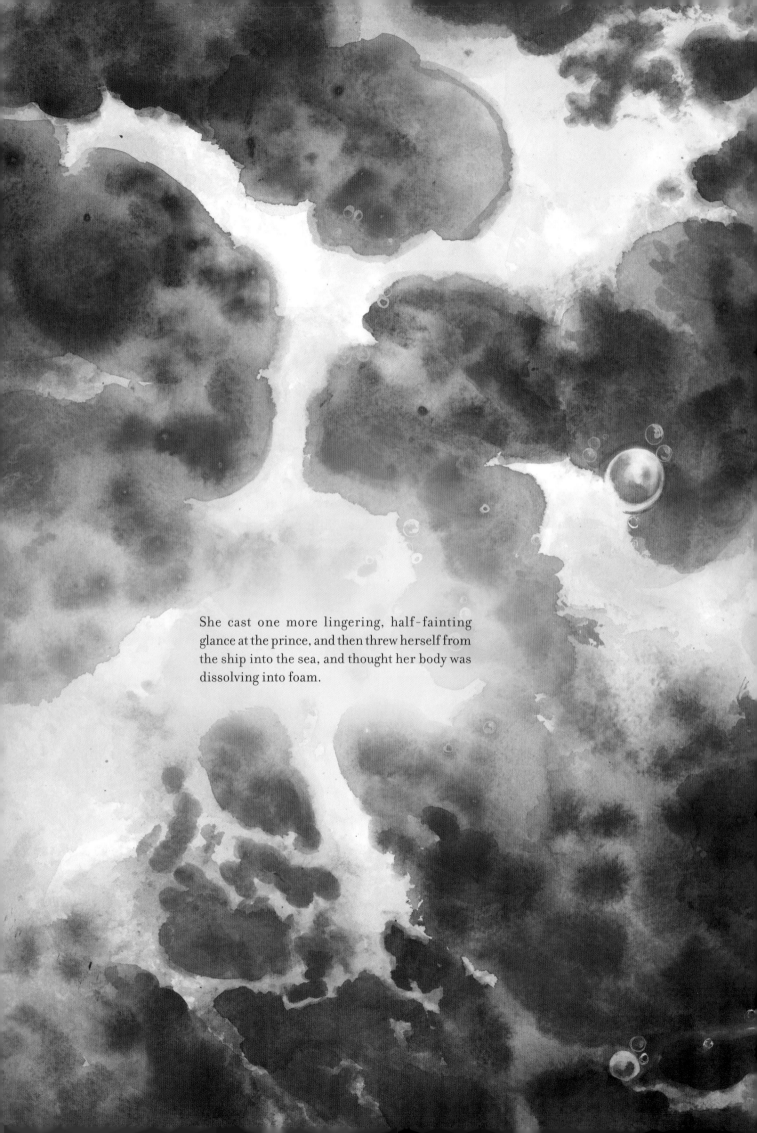

She cast one more lingering, half-fainting
glance at the prince, and then threw herself from
the ship into the sea, and thought her body was
dissolving into foam.

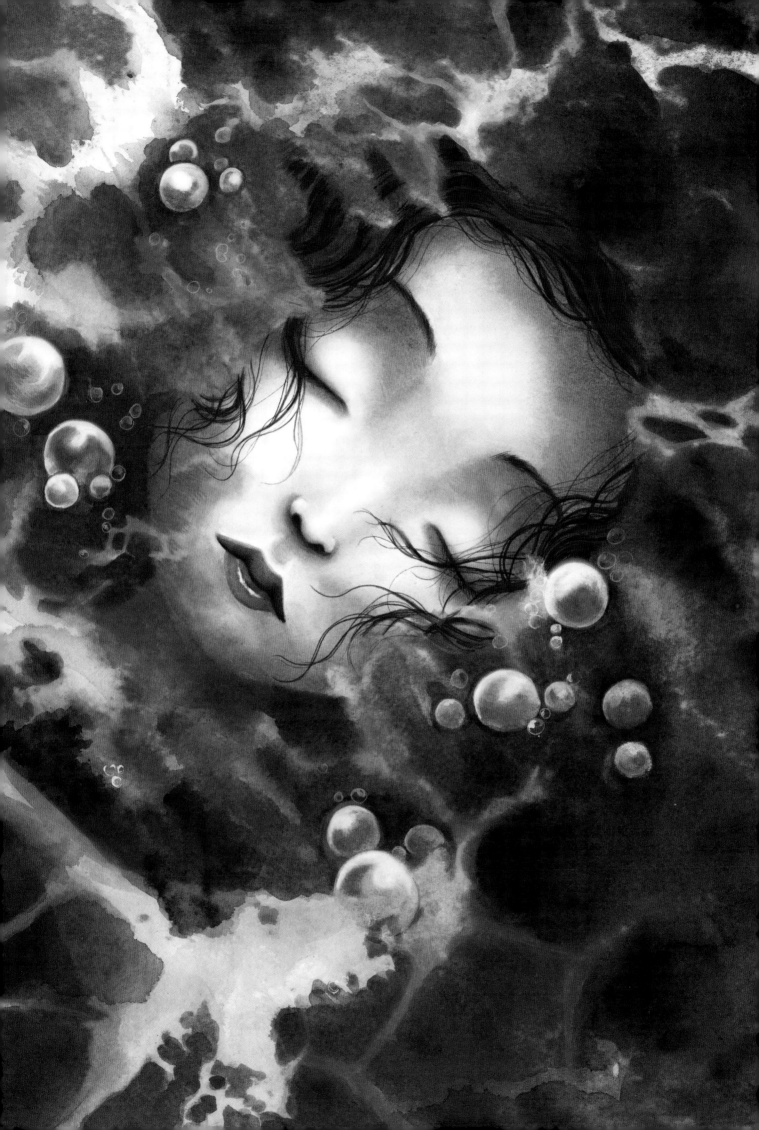

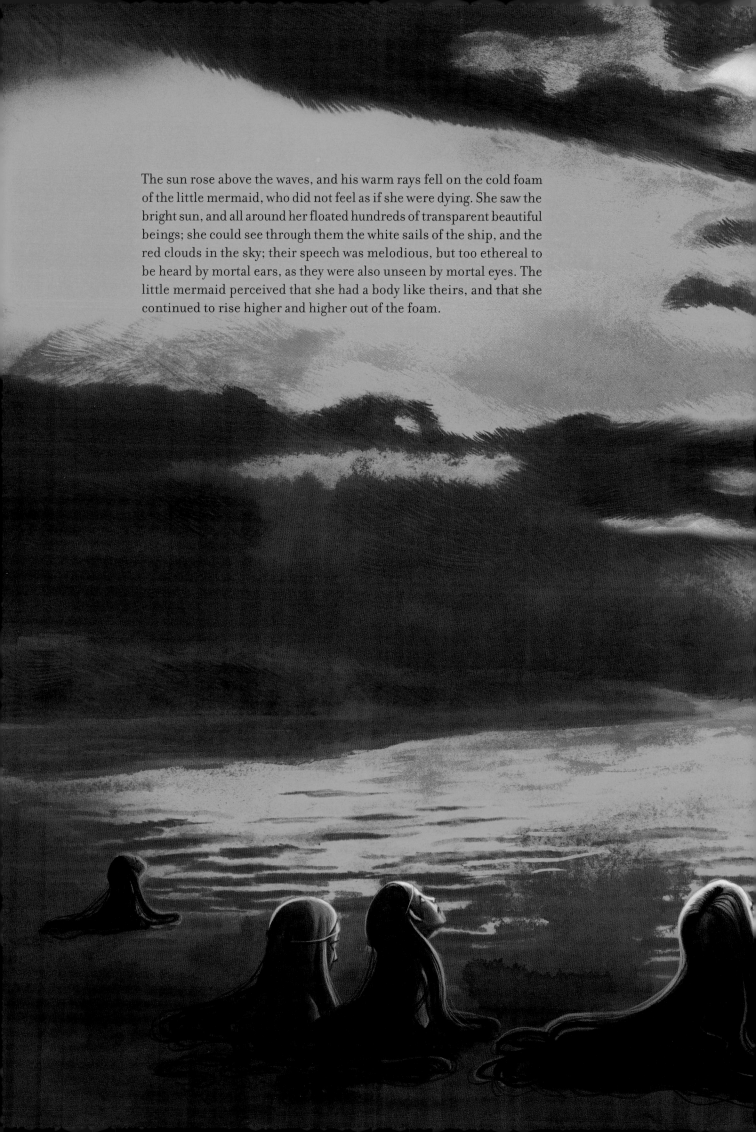

The sun rose above the waves, and his warm rays fell on the cold foam of the little mermaid, who did not feel as if she were dying. She saw the bright sun, and all around her floated hundreds of transparent beautiful beings; she could see through them the white sails of the ship, and the red clouds in the sky; their speech was melodious, but too ethereal to be heard by mortal ears, as they were also unseen by mortal eyes. The little mermaid perceived that she had a body like theirs, and that she continued to rise higher and higher out of the foam.

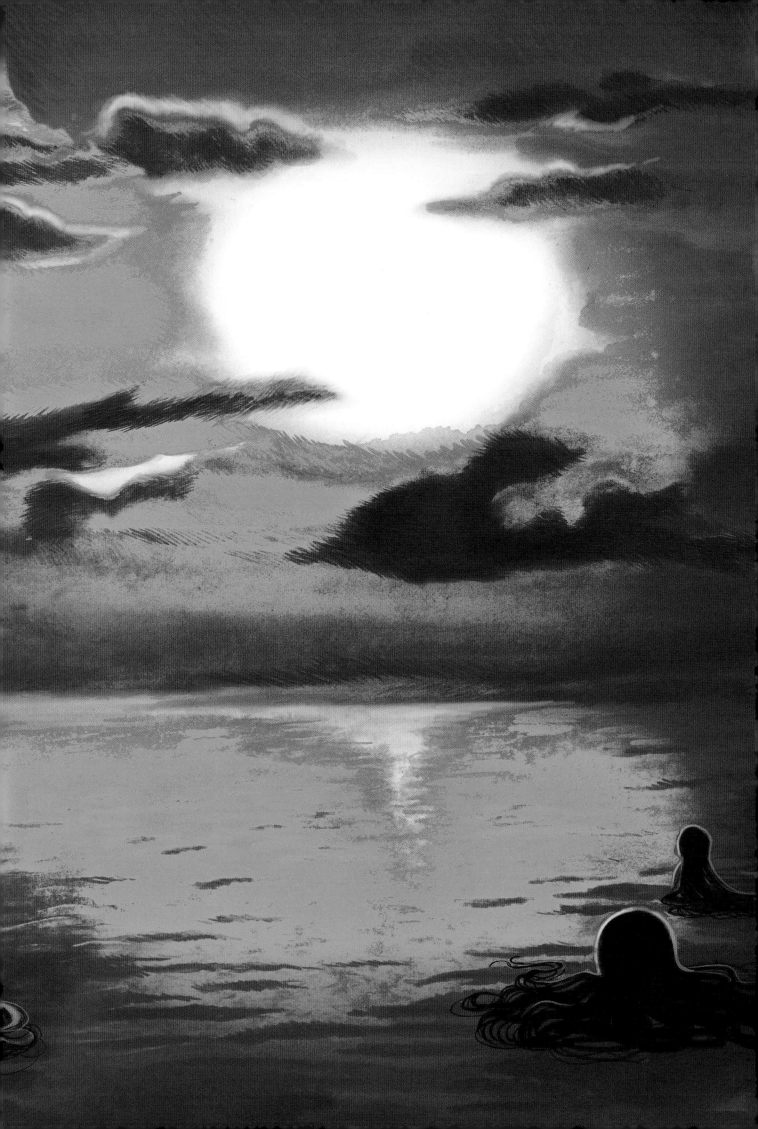

"Where am I?" asked she, and her voice sounded ethereal, as the voice of those who were with her; no earthly music could imitate it.

"Among the daughters of the air," answered one of them. "A mermaid has not an immortal soul, nor can she obtain one unless she wins the love of a human being. On the power of another hangs her eternal destiny. But the daughters of the air, although they do not possess an immortal soul, can, by their good deeds, procure one for themselves. We fly to warm countries, and cool the sultry air that destroys mankind with the pestilence. We carry the perfume of the flowers to spread health and restoration. After we have striven for three hundred years to all the good in our power, we receive an immortal soul and take part in the happiness of mankind. You, poor little mermaid, have tried with your whole heart to do as we are doing; you have suffered and endured and raised yourself to the spirit-world by your good deeds; and now, by striving for three hundred years in the same way, you may obtain an immortal soul."

The little mermaid lifted her glorified eyes towards the sun, and felt them, for the first time, filling with tears. On the ship, in which she had left the prince, there were life and noise; she saw him and his beautiful bride searching for her; sorrowfully they gazed at the pearly foam, as if they knew she had thrown herself into the waves. Unseen she kissed the forehead of her bride, and fanned the prince, and then mounted with the other children of the air to a rosy cloud that floated through the aether.

"After three hundred years, thus shall we float into the kingdom of heaven," said she. "And we may even get there sooner," whispered one of her companions. "Unseen we can enter the houses of men, where there are children, and for every day on which we find a good child, who is the joy of his parents and deserves their love, our time of probation is shortened. The child does not know, when we fly through the room, that we smile with joy at his good conduct, for we can count one year less of our three hundred years. But when we see a naughty or a wicked child, we shed tears of sorrow, and for every tear a day is added to our time of trial!"

THE END

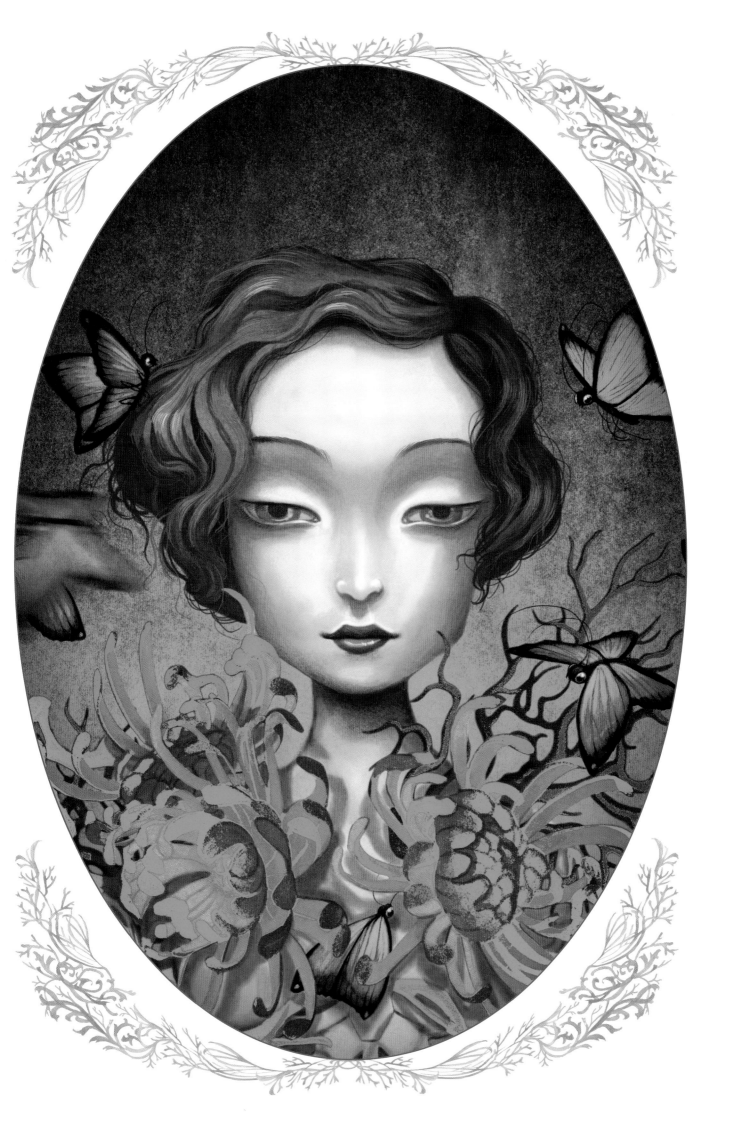

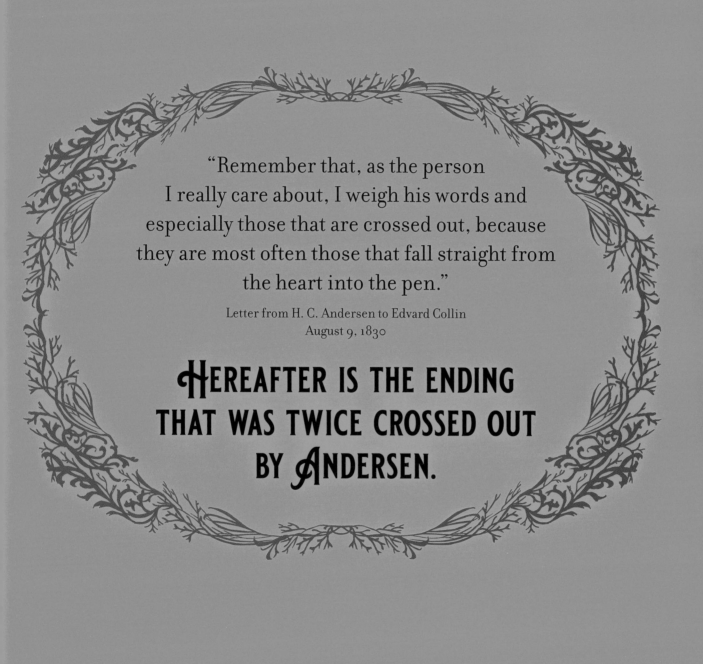

"Remember that, as the person
I really care about, I weigh his words and
especially those that are crossed out, because
they are most often those that fall straight from
the heart into the pen."

Letter from H. C. Andersen to Edvard Collin
August 9, 1830

Hereafter is the ending that was twice crossed out by Andersen.

"I will endeavor to gain an immortal soul," says the little mermaid. "I will, in the other world, be reunited with he, to whom I gave all my love. I will fly to the houses of the rich and the poor, I will float invisibly through the room where the children are sitting, and the good children I meet will reduce the length of my ordeal!"

THE END

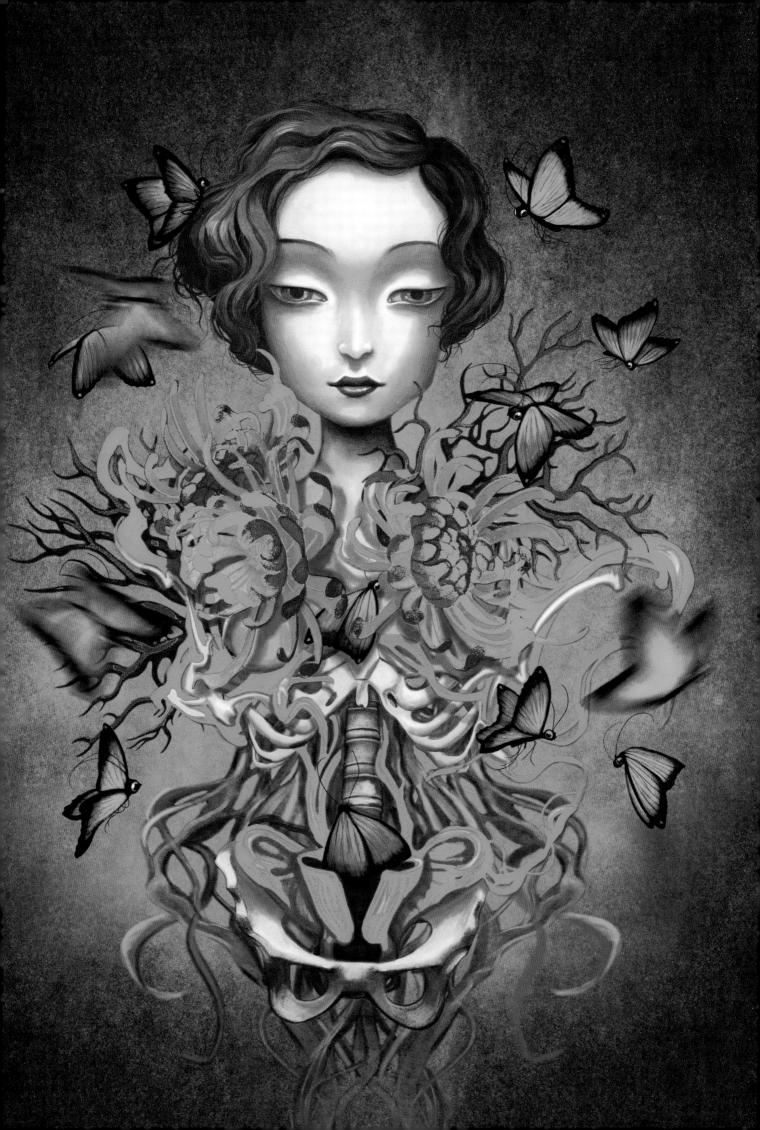

MESSAGE
IN A
BOTTLE

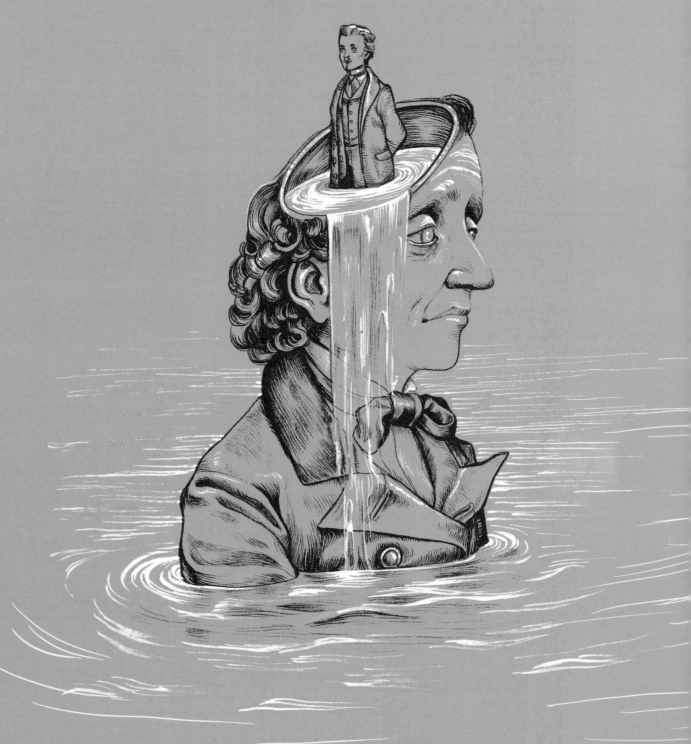

Letter from H. C. Andersen to Edvard Collin

Hamburg, May 19, 1831

Dear Collin!

[. . .] Of all the people I know, you are the one I consider in all respects as my true friend. May you remain one always, dear Collin; I really need a candid heart, but, my friend, the one that I can love as such must have spirit. I must, in this regard, be able to respect him, and that's what so fundamentally lacks in the few people I like, you are the only one, of the same age, that I genuinely feel close to.

I also have a prayer, you may laugh, but will you some day make me happy, give me proof of your esteem—when I deserve it—so—yes. Do not be angry!—Say "thou" to me![1] I will never openly ask you to do so, it must happen now, while I'm gone. If you are opposed to that, never again talk to me about it. I will, of course, never express it again! In your first letter I receive, I will see if you had wanted to make me happy, and I will then toast you, and it will come straight from my heart. Are you angry? You cannot imagine with what a beating heart I write these lines. But let's leave it at that. [. . .]

Yours, devoted with all my heart,
Andersen

1. Translator's note: I use "thou" for the sake of convenience here to mean a more familiar way of addressing someone, in the same way the French use "tu" instead of "vous." The original Danish also has this distinction, which doesn't exist in English.

Edvard Collin's response to H. C. Andersen

Copenhagen, May 28, 1831

Dear Andersen!

[. . .] I now come to a point in your letter, which . . . How can I make myself clearly understood, dear friend? I cannot convince you with reasons because they can probably not be written here, but, because I am your friend, you must take my word for it. You must be absolutely convinced that this is a character trait of mine that I am revealing to you in all its truth. It is only on this condition that I can avoid being misunderstood by you, which I fear I would be. I therefore wish to make clear my feelings about addressing each other as "thou" going forward.

As I have just underlined, Andersen, you must take my word for it. I speak honestly! When I am, say, in the joyful company of other students and one of them asks if we can address each other as thou, then I say yes, partly because I've not had time to gather my thoughts in the moment and partly so as not to offend the person who seems to think they are entering into a more friendly relationship with me. I remember one time, and one time only, I had been drinking with a young man and had addressed him as thou upon his request, I then, after some reflection, persisted in addressing him as you. And even though I felt uncomfortable offending this man, I have never regretted it. Why did I do it? This was a man I had known for a long time and that I liked very much. Something in me, I can't quite explain, clearly pushed me to do this. [. . .] And so, when someone I've known for a long time that I respect and like suggests addressing me as thou, this inexplicable and unpleasant feeling suddenly comes over me. [. . .]

[. . .] The people I address as thou mostly go back to my childhood years, partly to these light-hearted moments that do not leave time for reflection, partly to times when retracting myself would have been uncomfortable. But by explaining this, I am showing you [my] sincerity towards you, in that, rather than hiding from you, I am revealing myself to you [as] I do so here where I can so easily be misunderstood.

But no, Andersen! You cannot misunderstand me! And why this change in our relationship? Is it to give others a sign [of] our friendly relations? It would be superfluous and unimportant for both of us. Is our relationship [not] pleasant and useful to both of us? Why then initiate it in a modified form, a form which in itself rests on something so unimportant, but does, as I said, make me feel uncomfortable? I admit I am a bit of an eccentric in this regard. However, in the same way that I am saddened that this matter was brought up in the first place, so it should be as you wish, supposing that this is but a simple idea on your part, [because] to offend you, by God, I would not want.

But once again, Andersen! Why should we make such a change? Let us no more talk about it. I hope we both forget this mutual communication. When you return home, I will be in Jut[land] and we will not see each other before winter. There is no question of getting angry at your request. I do not misunderstand you and I do hope that you in turn do not misunderstand me. [. . .]

Your friend
E. Collin

Letter from H. C. Andersen to Louise Collin, Edvard's sister

Friday evening, 10:30 p.m., September 21, 1832

Whilst you are probably returning from the Comedie in Nygard,[1] I write this letter, I dream of you, I think of you. Day after day, everything that is in any way connected to me increasingly turns to poetry, my entire life appears to me as a lyrical poem, and you are really starting to play a role in it—don't be angry. Because Edvard is like a brother to me, it is therefore natural that you would become . . . his sister.

If only I had seen you at your house this afternoon, I find myself pining for you, I had so many things to tell you. [. . .]

Give my regards to your sister and to your mother, be sweet towards little Viggo.[2]

1. The Collins' summer residence in Copenhagen.
2. Viggo, aged two, son of Ingeborg Collin, the eldest Collin sibling.

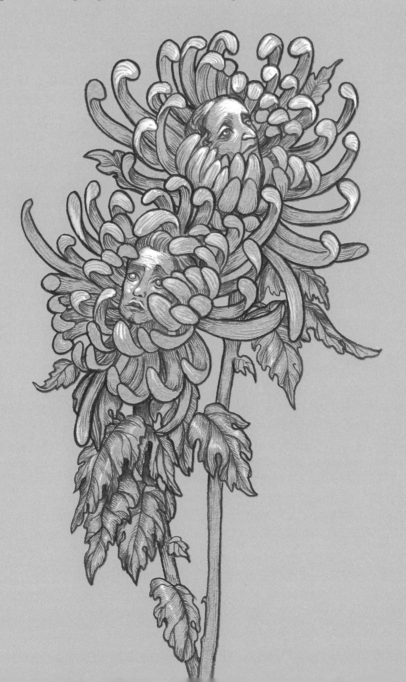

Letter from H. C. Andersen to Edvard Collin

Milan, September 24, 1833

[. . .] You said that I portray myself as Hemming,[1] that I have in fact used many of his expressions in my addresses to you, but believe me, dear friend, if you had known Schiller or Byron as you know me, you would have heard them use the same words to talk about much of what their poems express.

You wrote about my state of mind as being either too soft or sickly, precisely so, and yes, you may not believe this, but I consider it a great source of happiness to have you, to have your friendship and to have such a loyal friend. To make you understand this clearly, I must however touch upon a sore point, which may upset you and in fact, still brings me down. Our temperaments are somewhat different but it's precisely my softness that lets me yield to you! If I had had in me the feeling that drives me now, your way of being would have pushed me away when I didn't know you.

With all the trust of a child, I gave you my brotherly "thou" and you refused it! I cried, I went quiet, and since then, this issue has remained an open wound; but my softness, my semi-femininity have allowed me to become attached to you, and then I discovered in you so many wonderful qualities that I was obviously going to like you and bear in mind that it was only a small flaw amongst so many good things. Do not misunderstand me, Edvard—it is I who must now use this expression that you have so often dispensed! You and I must be honest towards each other, my spirit must appear to you in all its candor. Until I left, I was nasty enough to believe that your refusal to say "thou" was due to the fact that a potentially much better position than mine was awaiting you, and that this intimate "thou" could become awkward. By the eternal God, I no longer believe this, I consider it only to be a particularity of yours, and I apologize from the bottom of my heart. During the last two years, without knowing, you had made me suffer greatly because of something so puerile that I could have expressed in the form of a desire. But during those two years, by holding on tight to you, I have learnt to know the best of you, I have won you, you, that I will always love as a brother!

[. . .]

With brotherly love
Andersen

1. Hemming is a character from the dramatic poem "Agnete and the Merman" that Edvard Collin had roundly criticized in his previous letter in which he took Andersen to task for appearing to be its alter ego.

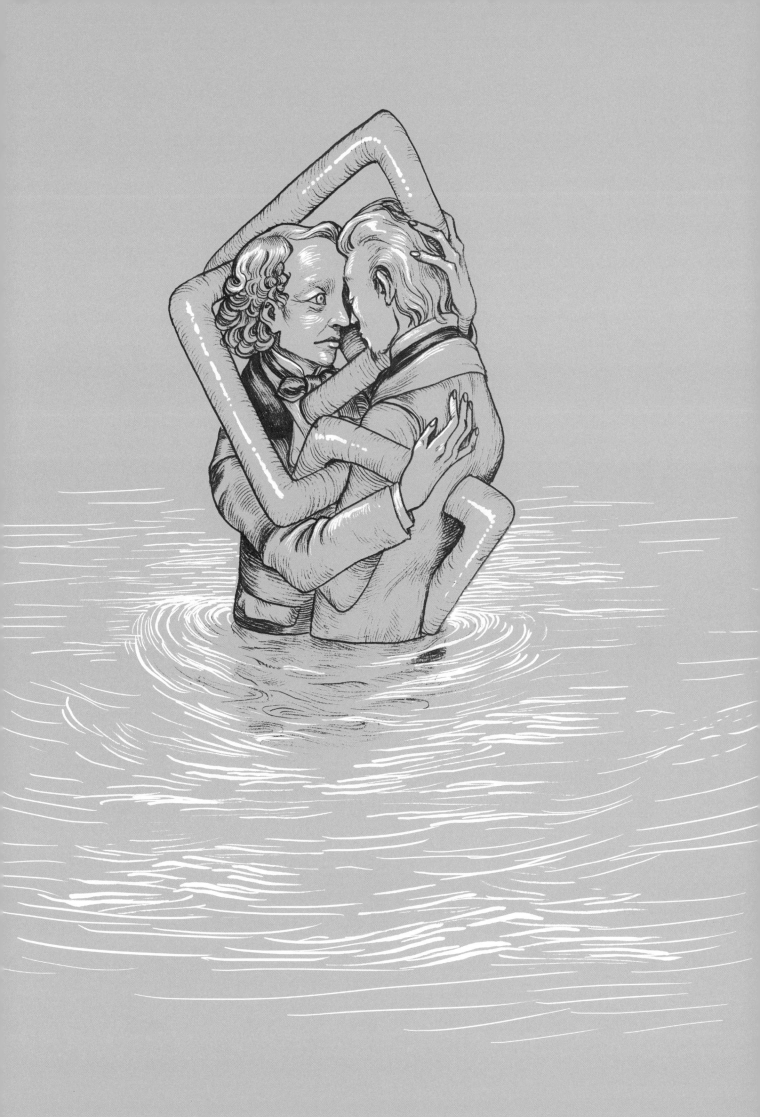

Letter from H. C. Andersen to Edvard Collin

Friday evening, 11 p.m., August 28, 1835

My dear, dear Edvard!

To write or not to write, that is the question! I should not but you did ask me and I will do it, because I am "good"! But I therefore also want to write a letter that is straight from the heart, one of those letters that I regret straightaway after writing. One of those letters in which I allow feeling to come first and reason to come sixteenth. Does this offend you? As time goes by, this will bring me comfort, because one's feelings are mocked, they can inject poison in one's blood or place the dagger in one's hand. I am Italian, you see. I pine for you; yes, at this exact moment, I pine for you as if you were a cute Calabrian with dark eyes and a burning gaze.

I have never had a brother, but if I had one, I would not have loved him as much as I love you, and yet—you don't return the sentiment! And this is torture—or perhaps, is this what so firmly links me to you! My soul is proud, the soul of a prince could not be more so; I held on tightly to you, I—*bastare*! This is a good Italian verb that in Nyhavn[1] can mean "shut up!" In my new novel,[2] there is a character I wrote with many of your traits in mind.

You'll thus see how dear you are to me and just with how much care I treat him. But you do have flaws and the character has more of them than you. Some of these are yours—can you forgive me? He hurts the hero of the story at one point, as I have done in my life—I conjured up a story that is unforgettable, unless I become noble and you find yourself in a position inferior to mine, which is nigh on impossible! I can only ever portray this character thus, even though I know it would displease you. I could also just give up on the novel even though it could be a supreme triumph.

Our friendship is a wonderful creation! No one more than you has been such an object of my wrath! No one more than you has caused such tears in my eyes, but no one more than you has, despite all this, been loved so loved by me. I would despair if I were to lose you. Our friendship perfectly fits this description, and yet—I fear we should not do it. It may seem artificial to show this contrast, which nevertheless remains harmonious! I could express to you all that my soul has to give, even my heart's deepest secret; but when it comes to our friendship, it resembles the "mysteries," it cannot be correctly analyzed.

Oh, if only God could make a very poor man out of you and a rich and distinguished nobleman out of me. Yes, then I would have to initiate you to the mystery and you would cherish me more so than now. Oh, if only there had been an eternal life, as there must exist one, we would understand and cherish each other. I would no longer be the poor man who needs interest and friends, there, we would be equal! All the forms would fall! [. . .]

Frederiksborg, goodbye, dear friend!

Yours,
H. C. Andersen

1. Copenhagen neighborhood where Andersen lived.

2. The novel *O. T.* was published in 1836, three months before Edvard's wedding to Henriette Thyberg. She and Edvard were engaged in 1832 and married on August 10, 1836. According to modern commentators, in addition to the fact that the characters of Otto and Vilhelm are the alter egos of Hans Christian Andersen and Edvard Collin, the scene in which Vilhelm, dressed as a woman, kisses Otto after sitting on his lap is a realization through fiction of the desire and love that Andersen felt for Edvard.

Letter from H. C. Andersen to Edvard Collin (never sent)

December 1835

My dear and loyal Edvard!

How often I think of you! How your soul will not open to me. I ask myself if you understand me, if you understand my love as I understand you!—At this moment, I see you, such as the happy spirits seem to see themselves; I could hold you close to my heart! Is it a passing fancy or overexcitement? No, it's a pure and noble sentiment. There must be times when you feel the same sentiment.

All good people must experience this sentiment. Now, there is between us no you, glacial. I say "thou" and your lip will meet me with the same sound you will pronounce only once you are in the other world. Oh, if only I was rich, we would fly together to Italy, this wonderful Italy, which I had not experienced to its full extent! Oh, if only we had been there together! If only we had been there, even a month!—Edvard, I have many young friends, but I don't love any of them as much as you because I don't pay attention to them. Am I vain?

I feel a strength of spirit whose ordeals the world has not seen, but me, the poor child, I feel myself evolve between the best and first of this era, and you are close to me in spirit and in thought; sometimes, I look up towards you and then I love you as I could love—the one I'll name for you when I will be with God! . . .

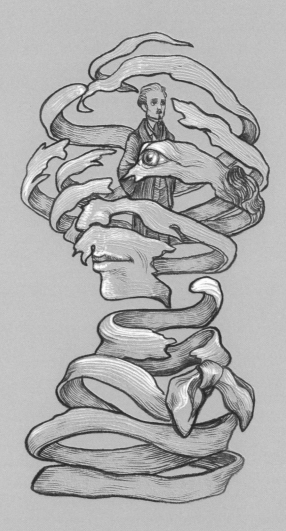

Letter from H. C. Andersen to Edvard Collin

Svendborg, August 4, 1836

My dearest best friend!

I arrived here yesterday afternoon, after a long wandering from manor to manor, and given that all the post addressed to Odense was being sent here, I went to the post office where I found a letter from your father. He wrote: "Thursday or Friday is the day of Edvard's wedding!"[1] I was happy but upset. A poem would probably leave you cold, neither will you probably be in the mood for a song. But I was of the opinion that, given that your closest friend (at least for my part) is a poet, none other than yourself should get a poem for their wedding.

However, having arrived here just yesterday and the post for Copenhagen leaving only Saturday, it is impossible for my wish to be granted. I will arrive *post festum*. You will already be a husband by the time my letter arrives. You have your adorable Jette.[2] Today and tomorrow, I will not stop thinking of you, one of these two days will have been the wedding day. Even though I cannot be there with you, not even with a poem, I will nevertheless be present. I can see you both, serious but happy.

In my heart, I pray to God: make them happy! My eyes water as I write these lines. My dear, dear Edvard! May God bless and guide you. Yes, you will be happy and you will deserve to be. Jette will be faithful and kind as she has always been. I can picture the domestic bliss; like Moses, I stand on the mountain and look towards the Promised Land, which I will never reach. God has given me many things in this world, but I am probably losing the best and happiest. One only has a home when one has a loyal and kind wife, when one sees themselves reborn through their dear children.

All this happiness now awaits you! I will be alone all my life. Friendship must therefore be everything to me, friendship must fill all those spaces, maybe this is why my words, my demands are so great, too great! But give me as much as you can. You are the one I love to the highest degree. I foresee my future with all it will lack. I will be alone and I must be. My reason, I hope, will always show me this clearly.

But my feelings are strong, as yours are, as you love your Jette, I also have loved! I have loved twice, but it was a trick, and yet, the tricked person is the one that suffers most, I will never forget this, even if you and I never speak of it. It is this suffering that we cannot even speak about to our dearest friend. And even though I have recovered, the pain only occasionally manifests itself in the healed parts. Maybe it would have been best for these words to have never been written. Yet, Edvard's marriage, by digging into my heart, has awakened all these memories.

He who can love twice will certainly return to love for a third time, you may think; but Edvard, this is exactly what I want God to keep me from. And he will! He only seeks that which is reasonable. I am not well today! The other day, I swam in a freshwater lake, which gave me a fever. I leave Odense on Wednesday, I will need 4 or 5 days to reach Nørager, today I received a friendly epistle from Emma telling me that the car would wait for me in Slagelse. I now await a letter from Nørager, why not on Sunday night, a letter from you, my dear, dear friend, and maybe Jette will also add a few words. I have left her here a little epistle. The wedding ceremony, I think, will take place in Elseneur and the following morning, the young couple will head into town. Tomorrow, when this letter arrives with the post, Jette and yourself will be sitting, as husband and wife, side by side. Happy people, both of you. See all that you have compared to your friend. Meanwhile, I fly towards the South. Italy is my bride! Live well! Live well! May God bless you both!

Le frère.

1. The father of the Collin children, Jonas, consciously avoided indicating the exact date of Edvard's marriage, as the family was worried that a jealous Andersen might turn up and make a scene.

2. The nickname given to Henriette Thyberg.

Letter from H. C. Andersen to Henriette Collin, née Thyberg,
future wife of Edvard Collin

Svendborg, August 4, 1836

My dear Edvard's Jette!

In thought, I kiss your hand and offer you my best wishes on this most important day in which you will join in union our dear and loyal Edvard. Even if I had not loved you, you would be, as his wife, close to my heart; but as you are, you are infinitely dear to me, I truly appreciate your excellent qualities and believe you will make him very happy.

Things have happened with you as they did with Louise and Edvard: at the beginning, I didn't much like you; you see, I confess. You became Edvard's fiancée and I started paying you more attention; your beauty, I'd always seen it, but you sparked my interest, and I came to have a lot of respect for you and appreciate you now very much, and have done for a long time, independently of Edvard.

This is why I now wish to give you some advice as a wedding present! Do not let him hold all the power, do not let him become a bit weird, do not concede everything to him. He is a good-natured man, he is intelligent and his heart—yes, you've given him yours—is in the right place, at least he has that; but you must bring him to heel, take him the right way. Firstly, give him a little kiss from me [. . .]

Soon I will come and visit the little household, the young and beautiful bride, rejoice in your happiness and never lose the friendship. Your loyal and devoted,

H. C. Andersen

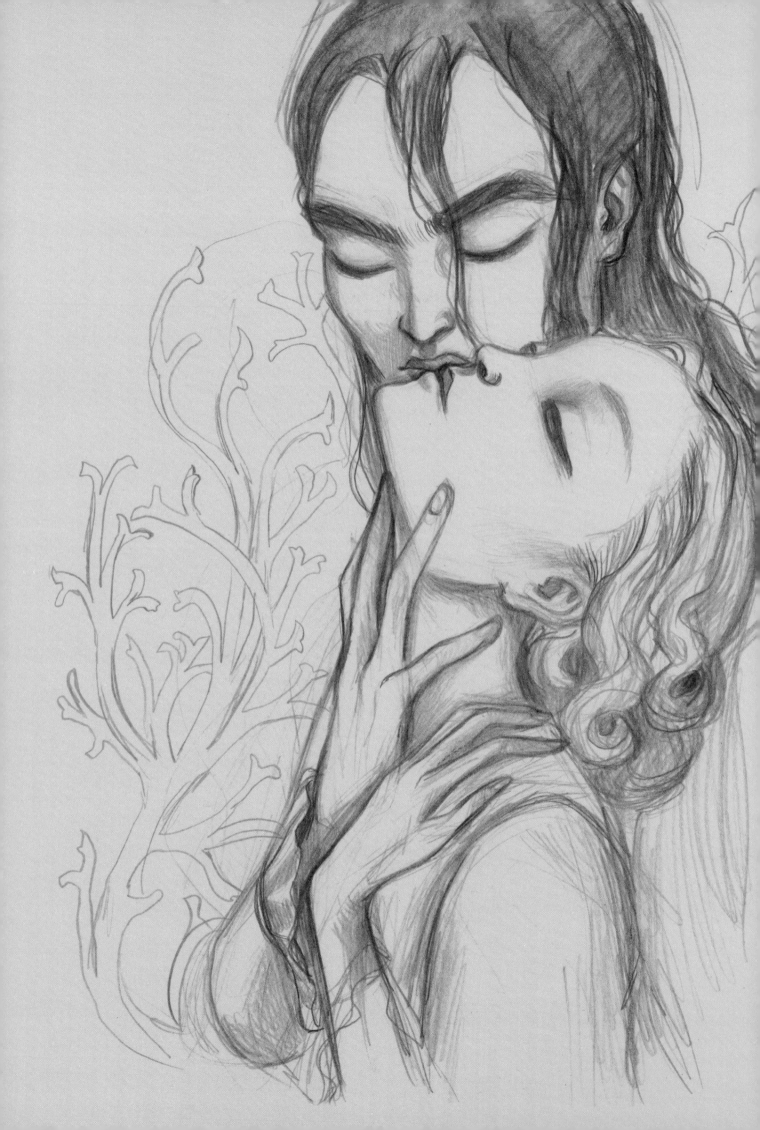

AFTERWORD
ANDERSEN'S NERVOUS LOVE
BY JEAN-BAPTISTE COURSAUD

No other tale of Andersen's has had so much written about it as "The Little Mermaid." Interpretations have either put the focus on the literary approach, comparing it to his other tales and texts, or on the biographical approach, by digging out explanations from Andersen's life and character.

But this biographical reading has become excessively rigid by insisting upon this analysis: Andersen portrayed himself as the prince, whilst the little mermaid embodied none other than Louise Collin. I, on the contrary, posit that the "literary camouflage," if indeed there is any, is in fact homosocial, if not homosexual, and not at all heterosocial, if not heterosexual.

In other words, behind the figure of the prince hides not Andersen, but Edvard Collin. Henriette Thyberg is the princess that the prince (like Edvard) marries; Andersen portrays himself as the little mermaid, having fallen madly in love with Edvard, especially from 1835 to 1836, the year of the wedding. But let's be clear, the aim of this afterword is not to maintain that Andersen was gay. And even if he had been, it is completely irrelevant to readers of "The Little Mermaid." Wilhelm von Rosen, who, in 1980, was the first to theorize about the Edvard–Hans Christian link as opposed to the Louise–Hans Christian one in his biographical reading of "The Little Mermaid," insists that "Andersen wasn't 'gay.' He simply fell in love with men, especially Edvard Collin with whom

he wanted to reach the stage of a sensible friendship."

This is why the American academic Eve Kosofsky Sedgwick prefers the term "homo-social," which has the benefit of underlining a historical continuity in the desire that one feels for a person of the same sex, given the fact that the term "homosexual" wasn't invented until thirty years after the publication of "The Little Mermaid."

When he published his 1907 thesis on the tales of H. C. Andersen, the first proper work of literary theory on the poet, Hans Brix didn't yet know what good hermeneutic fortune awaited him. As the initiator of the biographical reading, he considered it essential to know about personal experiences of the "great poets" and the conditions under which they wrote their work in order to understand it. As soon as it came to "The Little Mermaid," Brix's assessment dropped like a heteronormative guillotine blade: "The unfortunate love of the little mermaid towards the prince represents the poet and Louise Collin." Sixty years later, we read the same conclusion, this time under the penmanship of the structuralist Eigil Nyborg, whose use of adverbs is somewhat contradictory: "One cannot possibly contest the fact that [Andersen's] unfortunate love for Louise Collin has probably created this exterior circumstance that allowed the tale to emerge." A key element of the story's construction is nevertheless missing from Nyborg's interpretation: the prince's marriage to the princess.

Without the princess, the tale cannot end and the mermaid cannot die. Who could this woman be in the writer's own life, if Louise is the mermaid and Andersen the prince?

In order to explain his theory of this Louise–Hans Christian foundational link, and in the absence of a convincing letter in the correspondence between Andersen and the Collin family that Edvard published in 1882 under the title *Hans Christian Andersen and the House of Collin*, Brix claimed to have a letter, not published, but "the most interesting of all," the one reproduced on page 87. Not a word about the letters addressed to Edvard, even though they feature in the collection in which Andersen mentions the verb "to love" five times, and the substantive "love" once, when he addresses Edvard directly.

It is fairly clear that the feelings of the poet towards Louise are not of the same nature or strength as those he declared to Edvard. "Yes!" exclaimed Elias Bredsdorff, a renowned twentieth-century Andersen scholar, "one must be careful [not] to interpret Andersen's use of the word love too literally." Yet Andersen was very clear on the difference between *holde af*, "meaning a lot [to someone]" and *elske*, "loving" or "to love." In fact, in a letter from 1833 (I'll come back to this), captivating in its semantic ambiguity, he wrote to Edvard: "My pride yields to my love for you! I can't express what you mean to me," If researchers from Brix to Bredsdorff had not suffered from heteronormative blindness or had sported less selective glasses, they wouldn't have knowingly omitted to read a number of Edvard's sentences that underline his refusal to "play the part of an admirer or a sensible friend."

Edvard wrote: "I only wanted a 'mate' [...] He desperately wanted to find, in me, a 'friend from a novel,' but I wasn't worthy in that regard." On the face of it, conscious of his equivocal formulation, he explained his thoughts in a footnote, which mentions the "nervous love" that Andersen felt for him. He even went so far as to quote a "witness" he refused to name, who had written to him: "Can you finally write a letter to this strange being that is Andersen. It bothers me to see and hear [...] that he only lives, he only exists in part through you, that his first thought when he wakes up and his last when he sleeps concern Edvard Collin." Basically, he was perfectly aware of being loved by Andersen. Even his son Jonas confirmed it more directly.

In his book *H. C. Andersen and the Collins, A Legitimate Defense*, published in 1928, Jonas touched on the "erotic disposition" of the writer, a lexical fig leaf to avoid using the scandalous term "homosexuality": "In order to avoid Andersen's kisses and hugs, Edvard Collin felt he had to refuse to call him 'thou,'" a sentence that at least seemed to lift the veil that enveloped Edvard's response to Andersen in which he explained this refusal. The proof exists but nobody wanted to read it. The Danish academic Dag Heede in his 2004 book *Hjertebrødre : krigen om H. C. Andersens seksualitet (Heart Brothers: The War for H. C. Andersen's Sexuality)* offers an interesting conclusion to this excessive biographical spin: "It's a tragic paradox to see most of the Danish research on H. C. Andersen attaches such an absurd and over-the-top level of importance to biographical information and only insists on its use if it confirms the construction of Andersen as a heterosexual man."

In his *Will to Knowledge* (the symbolic title of this afterword), published in 1976 as the first volume of *The History Of Sexuality*, Michel Foucault explained how the creation of the words "heterosexual" in 1868 and especially

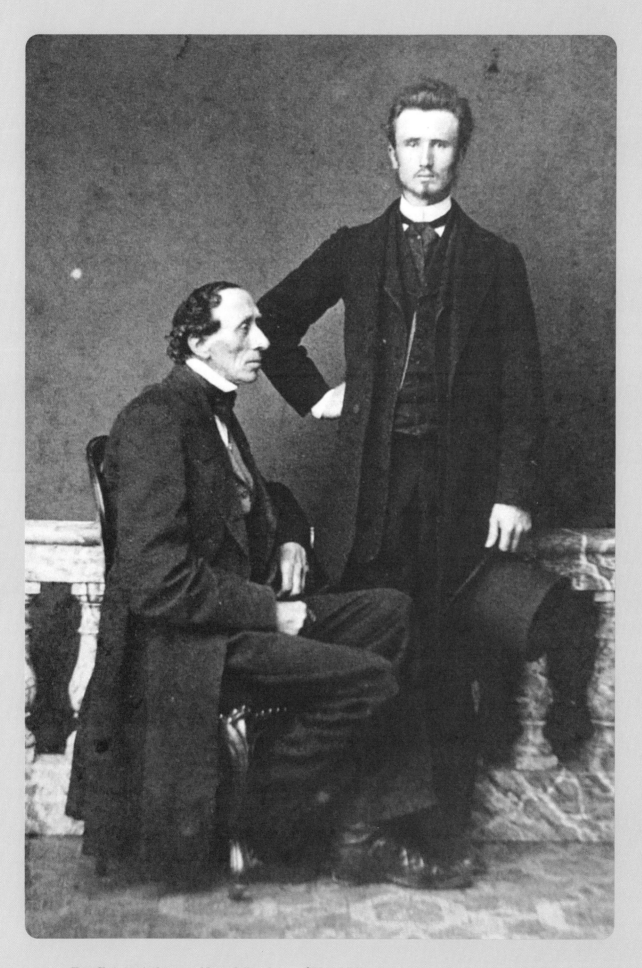

Hans Christian Andersen and Jonas Collin, the son of Edvard Collin. Jean Barberon, Bordeaux, January 9, 1863.

"homosexual" in 1869 by the Hungarian Karl Maria Kertbeny—whom Andersen met a number of times in Dresden and then Paris—made homosexuals a "species."

Named and therefore nameable, identified and now identifiable, homosexuals became a subject of study and interest both by those who were homosexuals themselves and by those who were against them. But it was also a subject those in power could condemn and repress, including those in, according to Heede, "psychiatry, jurisprudence and even literature." Andersen didn't escape this, and Danish commentators still fell over themselves to bring him back into

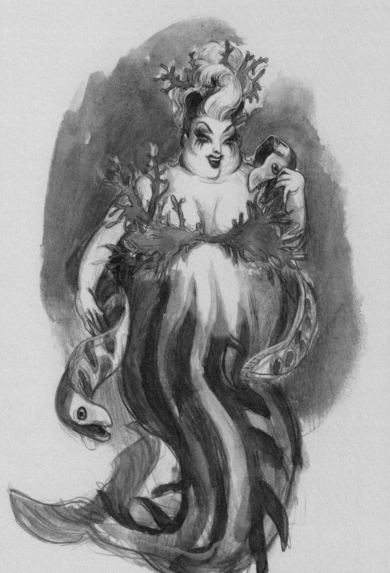

the fold of the heterosexual species. They had a choice of a number of strategies, the aim of which was the "forced heterosexualization" of Andersen, as Dag Heede subtly called it.

Between the pathologization of the poet—"a blatant psychopath," according to Brix—his psychiatrization—Hjalmar Helweg and Nyborg both talked about a "diagnosis" when they were forced to write the qualitative "homosexual"—his effeminization—"an effeminate nature" or "an effeminate quality to a certain part of a soul," according to Hilding Ringblom in 1997—all these arguments contribute to the "Danish heterosexual construction of Andersen," insisted Heede. Never ones to shy away from an aporia when it came to sex and sexuality, Andersen scholars shut down all homoerotic sentiment felt by the poet and insisted that "he was simply an onanist" as proof of his non-homosexuality. French Scandinavian writer Régis Boyer wrote a whole page about it in *La Pléiade* in 1992.

Likewise, when they very reluctantly admitted that Andersen had fallen for a man who they don't name, scholars immediately listed his female objects of desire—Bredsdorff in fact wrote a whole two pages about this. The ultimate strategy was to boot the hypothesis of a homosocial Andersen out of Denmark by insisting on his foreign character.

In his biography, clearly the go-to book on the poet according to the Copenhagen Royal Library website, Andersen scholar and creator of the H. C. Andersen Center in Odense, Johan de Mylius talked about "a very popular theory, especially in Germany (and more recently and repeatedly in England), which sees Andersen as a homosexual." In other words, to paraphrase Dag Heede and

his exquisite turn of phrase, the idea was to avoid having "a queer as a national poet." Only, queers always triumph!

And so, in 2004, when the Danish Culture Minister published his "cultural canon," Andersen's "The Little Mermaid" was of course amongst the twelve literary works selected. Yet, the conclusion of the official line of thought rests on a strangely (or not!) rarely commented-on passage that Andersen summed up in two sentences in the tale. (I'll come back to this.)

A hundred years after Brix's heteronormative verdict, the wider recognition of the theory of Andersen's homosexuality was a huge victory, as much for its truth as for the changed meaning of the symbols and images. But when the prince gives the mermaid men's clothes, we must look closer. Isn't the tale here tackling, in fact, the relationship between two men? One attracted to women, and the other who prefers men? Basically, it's the story of a homosexual man who falls tragically in love with his heterosexual friend, in which case it's much easier to understand why the girl wearing men's clothes can't speak, suffers all these ordeals, and doesn't get the one she loves in the end.

In her *Epistemology of the Closet*, published in 1990, in which she analyzed novels from the late 19th century that included depictions of homosexual men, Sedgwick (who, along with Judith Butler, developed the queer theory that serves as a frame of reference for this afterword) demonstrated how, following Foucault's earlier work, the creation of the word "homosexual" revitalized another continuity: the one that sought to rank the preferences of desire, where heterosexuality was always more valued and enhancing, and homosexuality was always more belittled and belittling. As the comments on Andersen

show us, the idea was to discredit homosexuality, rendering it disqualifying in order to establish a heterosexual invariant: here, the Louise–Hans Christian link to the detriment of the Edvard–Hans Christian link.

Ultimately, for Sedgwick, in society as in literary analysis, as soon as we bring up a homosexual or homosocial motif we get told, "That didn't happen, it doesn't change anything, it doesn't mean anything, it doesn't have any interpretative consequences. Stop asking, stop asking here, stop asking now." Let's turn that first part of the axiom onto those killjoys, those spoilsports, as Sedgwick so wonderfully invited us to do.

Let us show how this biographical reading, with its insistence on the Louise–Hans Christian foundational link, has interpretative consequences. But in favor of another reversal, let us bring our minds back to the author's life and remember some key dates, as milestones marking the creation of "The Little Mermaid":

April 1835: The publication of "The Improvisor."

1835: A love letter from Andersen to Collin, never sent.

February 1836: The first mention of the tale under another title.

May 1836: Edvard Collin and Henriette Thyberg's wedding is announced to Andersen.

August 4, 1836: Andersen's arrival at the manor of Lykkesholm to write "The Little Mermaid," and the letter to Edvard in which it is made clear that Andersen isn't invited to the wedding.

August 10, 1836: Edvard's wedding.

1836: The publication of *O. T.*, written in 1835, whose protagonists are the alter egos of Collin and Andersen.

Above, the crossed-out conclusion in the tale's original manuscript.

January 23, 1837: Andersen rewrites the ending of "The Little Mermaid."

February 11, 1837: A letter from Andersen to Ingemann in which he explains that he changed the ending.

April 7, 1837: "The Little Mermaid" is published.

Now that these are set, let's backtrack and focus on the way in which Andersen ends his tale. Because it's the ending specifically that over the decades has consistently angered commentators. If Brix compared the ending to "what a nurse becomes for disappointed hearts," it seemed "artificial" to Nyborg, who, with his Jungian analysis of 1962, did not understand that the little mermaid chooses salvation even though she is the anima (the feminine part of men) of the prince—nevermind that Andersen mentioned his "semi-femininity" in a letter to Edvard Collin.

Not at all, that's the whole paradox of salvation, replied Søren Baggesen in 1967 in a more theological reading: The love of the little mermaid for the prince is only a way in which to gain an immortal soul and thus salvation. However, should we go against Baggesen, the little mermaid seeks first of all the love of the prince, just like love drives her at the end to not kill him; thus, love is an end and not a means. Conversely, we could go against Nyborg and say that the little mermaid, as the heroine, as she gives her name to this tale, should instead look for an animus. Could it be that, in fact, the prince is not symbolically Andersen? Wilhelm von Rosen stated more directly that Nyborg "cannot explain the resurrection of the mermaid through his analysis because he identifies Andersen as the prince."

If Nyborg and Baggesen have missed their analytical train, it's probably because they

omitted one important point, one known since 1920 with the publication of the original manuscript.

Effectively, "The Little Mermaid" shouldn't have ended that way. The little mermaid should have regained her voice after having been struck dumb and become subject once again. Hans Christian Andersen had indeed imagined another ending, dated January 23, 1837:

> "I will endeavor to gain an immortal soul," says the little mermaid. "I will, in the other world, be reunited with he, to whom I gave all my love. I will fly to the houses of the rich and the poor, I will float invisibly through the room where the children are sitting, and the good children I meet will reduce the length of my ordeal!"

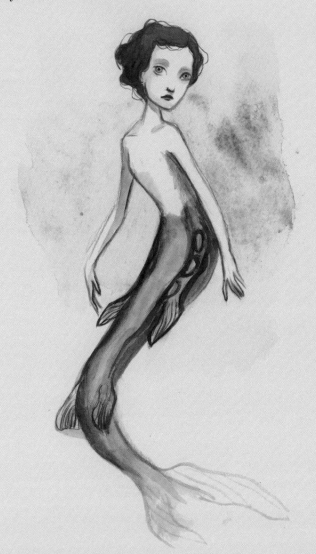

In this other denouement, everything rests in the phrase "in the other world," *hiin verden* in Danish in the original text, an obsolete phrase that means "the beyond." This *hiin verden*, this "other world," is the opposite of *denne verden*, "this world" or "here below." This expression is used when the little mermaid knows she is about to die and become foam because she has failed to gain the prince's love. Andersen wrote, "Her thoughts all turned to the night of her death, to everything she had lost in this world." The author distinguished between "this world," the temporal and immediate world of reality and life, the place of failure where the love that the little mermaid sacrificed everything for has not been granted, and the "other world," the immaterial and ulterior world, a world of death and the unreal, a place of success where the little mermaid will find the one she has adored and finally know requited love.

To be specific, the other world is, as the daughters of the air point out, "in the kingdom of God." Andersen also used these images in his novel *The Improvisor* and in his letter to Edvard, written that same year in 1835 but never sent, a sort of grand finale to the one written on March 7, 1833, in which he asked Edvard to offer him his friendship.

He wrote: "I am in a great state of excitement, due to the fact that I imagined finding in this world what I would call a loyal friendship." Once gained, this loyal friendship became, in 1835, a sensible friendship to not say love, but this time Edvard didn't return it. Let us cast our minds back to two specific elements in the original manuscript. The first is a passage, also deleted, in which the German Heinrich Detering noticed an error corrected by Andersen. The scene in which the prince and the little mermaid (in drag) ride together was originally followed by a tiger chase, a tiger that the mermaid kills by throwing her spear into his "hot open mouth" as he lunges, ready to attack the prince. Freud would be delighted by such a tableau. Yes, this is no Freudian slip.

The previous sentence contains these words: "He courageously hurled himself towards him [the tiger]." Andersen crossed out the pronoun "he," *han* in Danish, to replace it with *hun*, "she," in Danish because the subject is indeed the little mermaid. Although the pronoun was only changed by a vowel, the unconscious use of the former was certainly improper grammatically, but most probably not symbolically. Basically: "she" is "he"; properly, Andersen is the little mermaid. In fact, Detering believed that this was proof of the "literary camouflage" that we referred to at the start of this afterword. Maybe it was an absentminded error, but why would it have been made here, precisely within a scene that features cross-dressing?

The second element concerns the deletion of the ending in which the little mermaid regains her voice. A fresh look into the manuscript reveals that, in contrast to the words or phrases that are crossed out, this segment is in fact heavily outlined by a rectangle, which has been filled in with crisscrossing diagonal lines. Although it is fair to say that is the usual method of correction for longer passages, Andersen had very literally crossed it out. He heavily, roughly, implicitly or unconsciously, crossed out his own love for Edvard, a love Edvard never returned, as he wrote in his letter from August 4, 1836, as he was meant to be writing "The Little Mermaid": "You are the one I love to the highest degree. I foresee my future with all it will lack. I will be alone and I must be." Beyond the immense sadness of these words that made his (our) heart(s) ache, Andersen gave up, in so many words, on love.

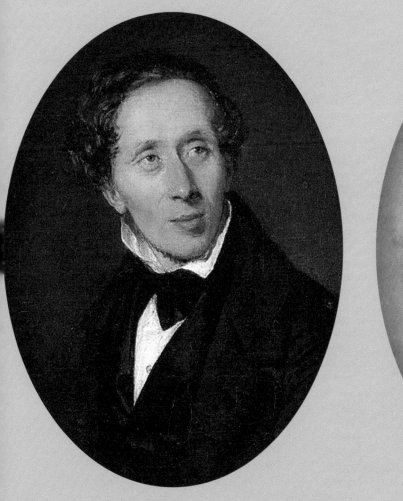
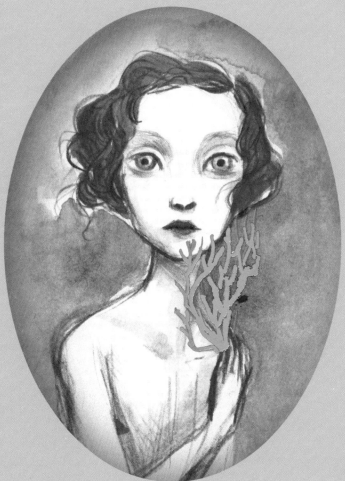

On the left, *Portrait of Hans Christian Andersen*, Christian Albrecht Jensen, 1836.

Like he gave up on this ending, he invalidated the essentially biographical reading, and even the one—mine—which argues for the interpretative Edvard–Hans Christian link.

After analyzing the manuscript with her colleague Nils Holger Németh Berg, Ane Grum-Schwensen, curator at the Andersen Museum in Odense and specialist in the author's original manuscripts, also reflected on this suppression. The inclusion of the phrase "in the other world" (*hiin verden*) could well be the author bidding "farewell" to the possibility of finding Edvard there. The second possibility, Grum-Schwensen posited, was that the mermaid finding her voice again would have been made redundant by the daughters of the air also finding theirs. Or even, thirdly, Andersen hadn't wanted to write more about this beyond. Thanks to Michel Foucault's subtle reflection, let's suggest perhaps a fourth hypothesis, which expands on the first hypothesis that sees him give up on love.

Foucault explained in *The Will to Knowledge* that far from censoring the discourse around sex, the powers that be in fact brought it to the fore. By promoting the importance of confession, they ensured people's dependency on them. They forced the "subjugation of men." The philosopher also taught us: "Confession frees, but power reduces one to silence; truth does not belong to the order of power, but shares an original affinity with freedom." The little mermaid's actions align with Foucault's supposition. Initially rendered mute by the powers incarnated by the witch, her family, and to an extent the prince, she confesses to herself that she has lost all her desires, love as well as terrestrial life. But, in keeping with her own truth, she doesn't sacrifice her freedom and, contrary to what these powers now require of her—killing the prince—she frees herself of her subjugation to them, and chooses the ultimate freedom that remains within her grasp: death. In that, she is a real children's fairytale heroine, in the sense that she takes charge of her own destiny, which is often emblematic of this type of character.

Andersen didn't stray from Foucault's explanation either. Despite his reluctance to write about the construction of his tales, he wrote in his letter from February 11, 1837, to Ingemann:

> I didn't allow the mermaid, unlike La Motte-Fouqué in "Undine," to gain an immortal soul by becoming dependent on this foreign creature: the love of a human being. It might be a mistake! It would be due to chance, and I would not accept it in this world. I let my mermaid take a more natural, more divine path. No poet to my knowledge has chosen such a path, this is why I'm happy to do so in my tale. You'll see for yourself!

Well, let's see indeed. And notice that the phrase "in this world" (*denne verden*) takes us back once and for all to the Edvard–Hans Christian link.

The explanation given by the author rings like a confession when he admitted having perhaps made a "mistake" by choosing this ending. But in the same way he freed the mermaid from her subjugation to the love of a man to join the "other world," he freed himself from his subjugation to his love for Edvard, whom he was sure to find "in the other world." Even better, reduced "in this world" to a besotted silence by the power that Edvard embodied, Andersen freed himself a second time, this time from Edvard. He decided to keep this autobiographical truth

to himself and chose the ultimate freedom that was still within his grasp as a writer and storyteller: crossing out his ending.

By way of a conclusion, I would like to one last time turn the axiom towards Eve Kosofsky Sedgwick ("stop asking here, stop asking now") and ask a series of questions to our readers. We could in fact ask ourselves why, throughout our entire schooling, we had to learn all about the lexical neologisms invented by Balzac but couldn't know anything about the many homosexual characters that populate his novels. Why did we have to learn all about the importance to French literature of Flaubert's Emma Bovary but couldn't know anything about his dalliances with young boys in Egyptian brothels, of which he wrote in detail in his diaries? Why did we have to learn all about the poetic revolution initiated by Rimbaud and his "I Is Somebody Else," but we couldn't know anything about his homosexual relationship with Verlaine? Why did we have to learn about all the possible heterosexual interpretations of "The Little Mermaid" in light of the letters and diaries of its author, without ever learning about all the masculine love that features amongst them?

Let's ask ourselves this instead: Why did we need to know all about Baudelaire's drug-taking when we were learning his poems? Why did we need to know all about the love between Alexandre Dumas and Marie Duplessis when we were reading *The Lady of the Camellias*? Why did we need to know which women inspired Théophile Gautier when he wrote "The Dead Woman In Love," when we simply wanted to read a vampire story? Why have we needed to learn for over a hundred years that the little mermaid is Louise Collin and the prince is Andersen, when Andersen was in fact the little mermaid and Edvard Collin the prince—Edvard, with whom he was desperately in love?

—Jean-Baptiste Coursaud

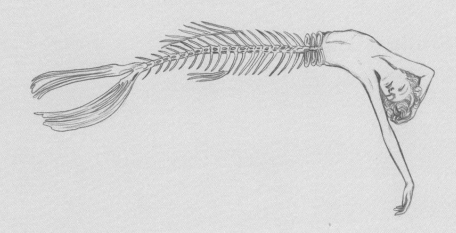

THE ARTIST

BENJAMIN LACOMBE was born in Paris in 1982. After studying at the ENSAD in Paris, he developed a rich and diverse artistic practice, including painting, *pierre noire*, volume modelling, set design, and pattern creation for textiles, and regularly exhibits his art. At Albin Michel Jeunesse, he oversees the Illustrated Classics collection, faithful rewritings or modern reappropriations of great classics, including *The Wizard of Oz* and *Bambi*. He also publishes books with original and powerful content and rich painted images, namely *Frida*, *Ondine*, and *Cécité Malaga*. These works have been translated and awarded prizes around the world.

THE WRITERS

Born in 1805 in Odense, Denmark, into a very poor family, **HANS CHRISTIAN ANDERSEN** is the author of poems, novels, and plays. But he will find global fame as a writer of fairytales, around 200 in total, the first of which were published in 1835. He reinvented the genre by injecting elements of orality, which became his trademark: "The Ugly Duckling," "The Emperor's New Clothes," "The Steadfast Tin Soldier," "The Snow Queen," "A Little Match Girl," and "Thumbelina," to name a few of the most famous. After his work was translated into German in the 1830s, he gained a wider notoriety in German-speaking countries than in his native Denmark, a fact he endlessly complained about; 1846 marked his full recognition as an author in his birth country. It wasn't until 1848 that the first tales were translated into French, and 1860 in the case of "The Little Mermaid." A keen traveler and letter writer, Andersen was also known for his paper cuttings. Following his death in 1875, he received a state funeral in the presence of the king of Denmark.

Born in 1969, **JEAN-BAPTISTE COURSAUD** is the author of over 150 translated works, mainly from Norwegian and Danish. He also works as a script consultant for German-speaking graphic novel illustrators.

To my love, who helps me through rough seas.

To all you brave artists of the present and the past who have made their evils
and their ambiguities into strong and profound works that have inspired me:
Tamara de Lempicka, Frida Kahlo, Rosa Bonheur, Eva Jospin, Hans Christian Andersen,
Lewis Carroll, Mel Odom, Leonardo da Vinci, Oscar Wilde, Jean Cocteau, Pierre et Gilles . . .

To the mermaid Cécile Jourlin and her super Triton, Étienne Friess.

Benjamin Lacombe

Library of Congress Control Number: 2023935461

ISBN: 978-1-4197-7199-6

© 2022 Albin Michel Jeunesse

Translation by Abla Kandalaft
Graphic design and production: Benjamin Lacombe
Layout: Frédérique Deviller

Originally published by Albin Michel in French in 2022 as *La Petite Sirène*.

Printed and bound in China
10 9 8 7 6 5 4 3 2 1

Abrams books are available at special discounts when purchased in quantity for premiums and promotions
as well as fundraising or educational use. Special editions can also be created to specification. For details,
contact specialsales@abramsbooks.com or the address below.

Abrams® is a registered trademark of Harry N. Abrams, Inc.

ABRAMS The Art of Books
195 Broadway, New York, NY 10007
abramsbooks.com